Where Jesus Walked

EXPERIENCE
the PRESENCE *of* GOD

KEN DUNCAN

INTEGRITY®
PUBLISHERS
Nashville

www.integritypublishers.com

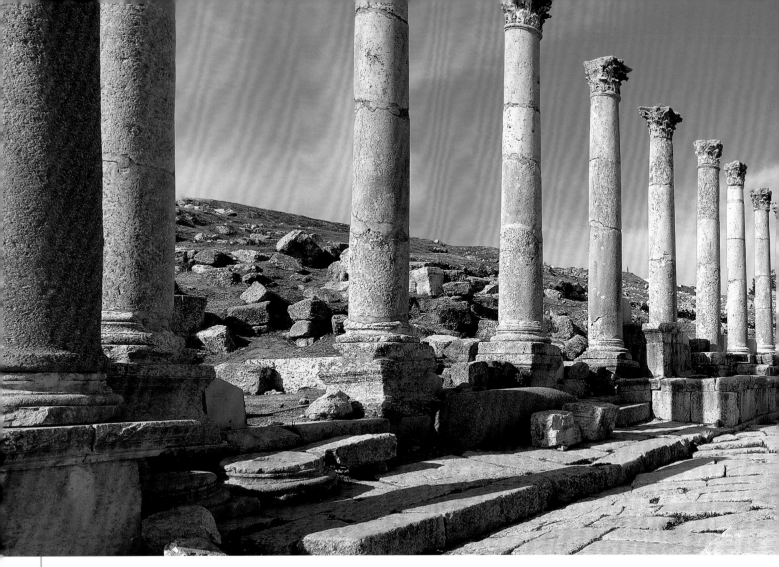

THE CARDO MAXIMUS, JERASH, JORDAN

This is one of the Decapolis cities that Jesus would have visited.

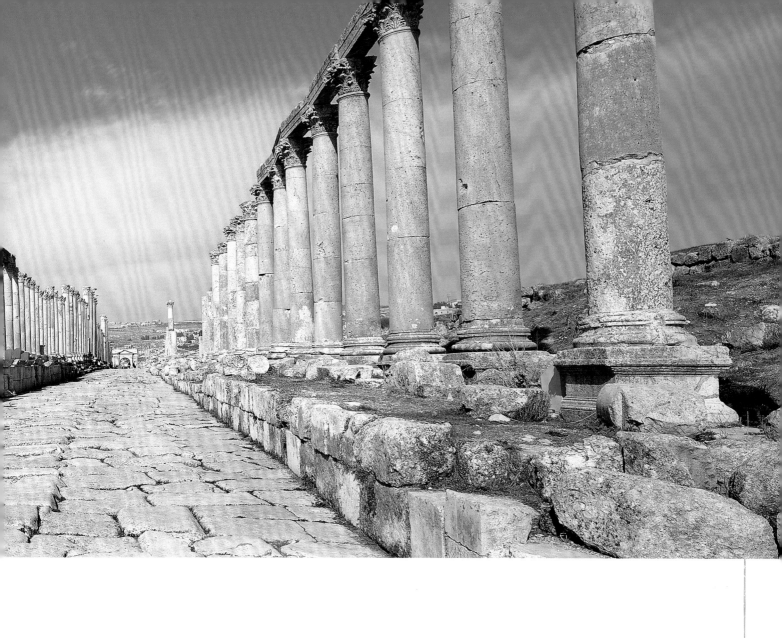

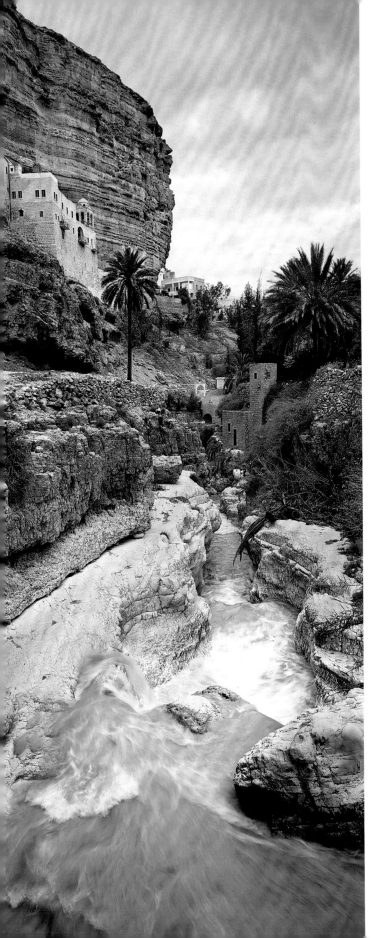

THIS BOOK IS *dedicated*

TO MY *best* FRIEND, JESUS.

WHEN I DECIDED TO *walk*

WITH HIM, THE *adventure*

OF MY *life* BEGAN.

THE MONASTERY OF ST. GEORGE, WADI QELT

The Monastery of St. George, "Dair Al Qelt," clings to the canyon (wadi) walls like a fairy-tale castle. [Wadi Qelt is a natural rift with high, sheer rock walls stretching between Jerusalem and Jericho. The narrow road lining the wadi was once the main way to Jericho.]

- Contents -

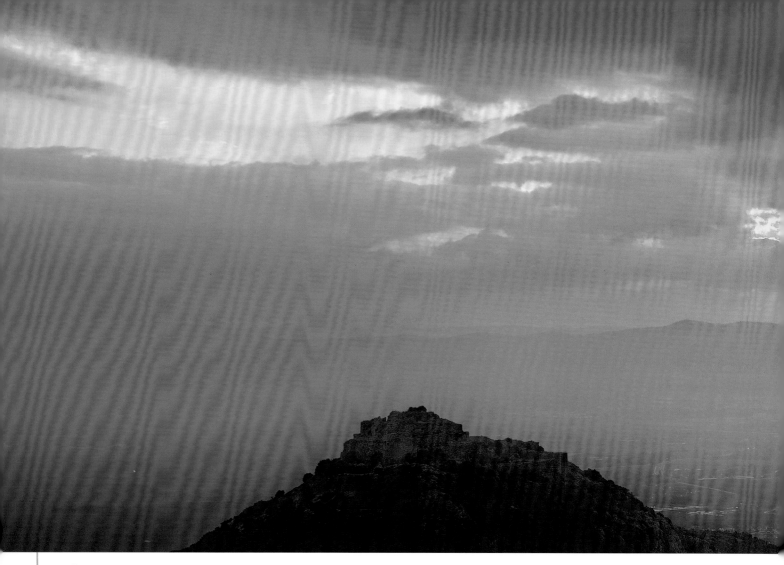

SUNSET AT NIMROD FORTRESS, VIEWED FROM MT. HERMON, ISRAEL

Nimrod Fortress is the largest and best preserved castle from the crusader period. Banias is prominently located in the valley below this castle.

First I would like to thank my beautiful wife Pamela and wonderful daughter Jessica for their love and support. Thank you to Charlie Asmar, a good friend and the greatest guide in Israel, Palestine, and Jordan (charlieasmar@yahoo.com). Thank you to Safwat Elbanna for his fantastic assistance in Egypt. Thank you to Jim Reimann who shared with me his love of the Holy Land. Thank you to Janet and the team at CFL Print Studio for their assistance with the prepress work. Thank you to Rob, Dave, Neil, Russ, and the rest of the enthusiastic team that Byron Williamson from Integrity put together for this project. Thanks also to the many others who helped along the way and God bless you all.

Ken Duncan

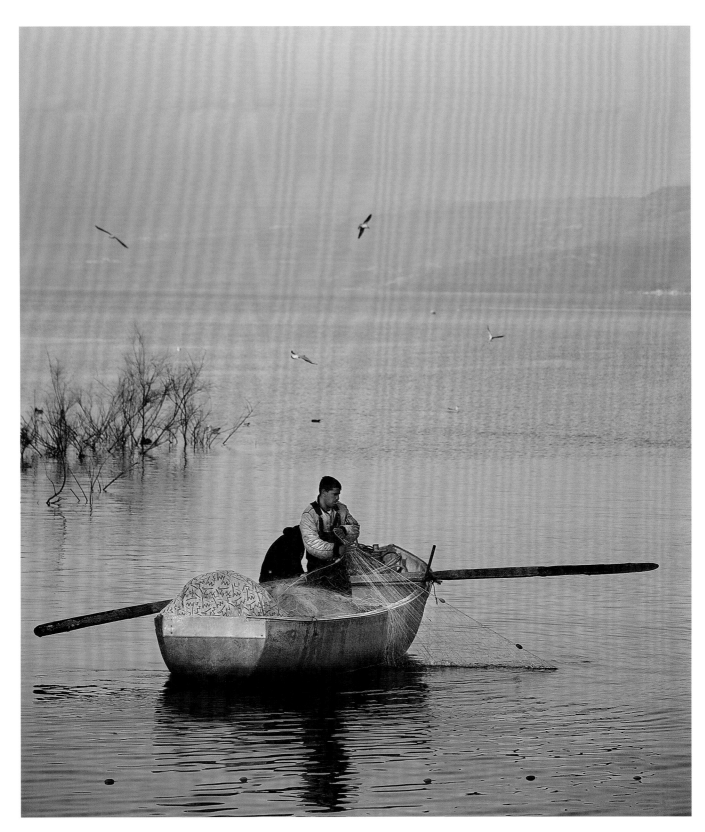

Where Jesus Walked

For this book, I endeavored to follow in the footsteps of Jesus Christ, the greatest man who ever walked this earth. His life had such a profound impact on humanity that he left a tremendous trail of evidence and influence. Hopefully, as you share in this adventure you will gain a deeper knowledge about the reality of this man Jesus and the marvelous purpose of his selfless journey.

Where Jesus Walked is one of the most difficult projects I have ever undertaken as a photographer because my impressions of the Holy Land had little to do with the reality of how the area is today. To verify the locations and the timing of Jesus' travels, I have had to sort through a veritable mountain of research material. I have presented many locations and events that to me are unquestionable points of Jesus' journey. I have also shown many other places because of traditional information. I am not saying the journey I have outlined is exactly correct, but it is my best attempt. In some cases I have presented a couple of possible locations. My intention is not to overwhelm you with information and opinions but to give you a sense of the areas in which Jesus lived and traveled. Jesus' walk has left an indelible trail for any seeker of truth to follow. When confronted with the overwhelming weight of evidence concerning Jesus' journey, it is difficult to understand how anyone could doubt his existence or purpose. God loves us all so much that he sent his only Son to earth to make a way for us to live the miraculous journey God has intended for each of us. I hope the pictures in this book, along with the inspirational text, help draw you into a closer walk with Jesus.

Ken Duncan.

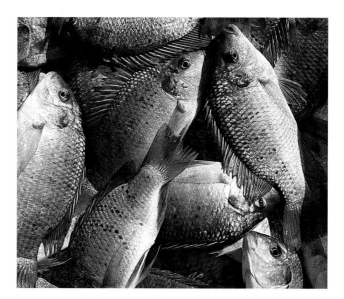

FISHERMEN FISHING FROM A BOAT, SEA OF GALILEE, ISRAEL *(left)*

ST. PETER'S FISH, SEA OF GALILEE, ISRAEL *(inset)*

MOSAIC, INTERIOR OF THE BASILICA
OF THE TRANSFIGURATION, MT. TABOR, ISRAEL

Promise and Anticipation

Brief descriptions and verbal sketches make up the account of Jesus' arrival. Tradition has supplied a host of suggestions, but the heart of the story beats with wonder and familiarity. Babies inspire great expectations. Yet babies arrive every day. What was so special about one baby, born in a wayside of the ancient world? All of us arrive the same way; why not the One sent to show us the way out? Why wouldn't the Savior of the common man choose the commonest of births? Why wouldn't the most expected take the least expected means of arrival?

Jesus was a fulfillment of ancient promises. Words of God's faithfulness echoed down through the centuries until that moment when "the Word became flesh and made his dwelling among us" (John 1:14). The familiar carol expresses it well: "The hopes and fears of all the years are met in Thee tonight." *Our* journey, the one we call "life," does have a hopeful destination. And the good news of the Gospels tells us that walking with Jesus takes us there.

MARY'S WELL, THE CHURCH OF ST. GABRIEL, NAZARETH, ISRAEL

According to tradition, the angel Gabriel first appeared to Mary while she was drawing water from the well now protected inside this church.

BUT THE *angel* SAID TO HER,

"DO NOT BE AFRAID, MARY, YOU HAVE FOUND FAVOR WITH GOD.

YOU WILL BE WITH CHILD AND GIVE *birth* TO A SON,

AND YOU ARE TO GIVE HIM THE NAME JESUS."

(LUKE 1:30–31)

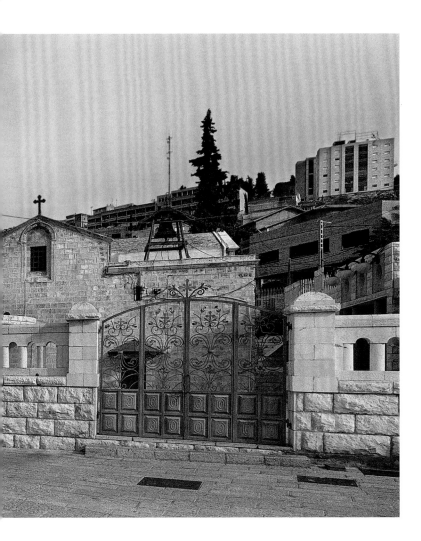

Let us notice at the very first glance *his miraculous conception.* It was a thing unheard of before, and unparalleled since, that a virgin should conceive and bear a Son. The first promise ran thus, *"The seed of the woman,"* not the offspring of the man. Since venturous woman led the way in the sin which brought forth Paradise lost, she, and she alone, ushers in the Regainer of Paradise. . . . His mother has been described simply as "a virgin," not a princess, or prophetess, nor a matron of large estate. True the blood of kings ran in her veins; nor was her mind a weak and untaught one, for she could sing most sweetly a song of praise; but yet how humble her position, how poor the man to whom she stood affianced, and how miserable the accommodation afforded to the new-born King!

Immanuel, God with us in our nature, in our sorrow, in our lifework, in our punishment, in our grave, and now with us, or rather we with him, in resurrection, ascension, triumph, and Second Advent splendour.

— C.H. SPURGEON

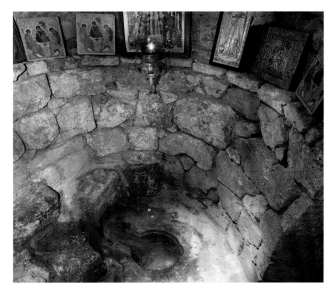

MARY'S WELL, THE CHURCH OF
ST. GABRIEL, NAZARETH, ISRAEL

[ELIZABETH] EXCLAIMED:

"BLESSED ARE *you*

AMONG WOMEN,

AND *blessed* IS THE

CHILD YOU

will BEAR!"

(LUKE 1:42)

THE CHURCH OF THE VISITATION,
EIN KAREM, ISRAEL

*This church stands on the site of the home
of Elizabeth and Zechariah.*

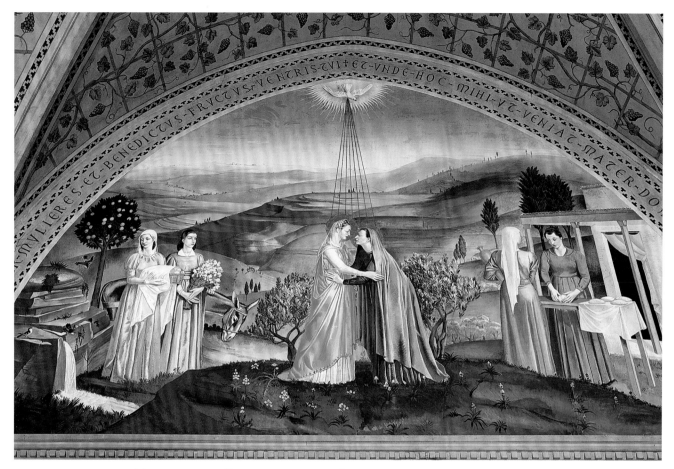

MARY MEETS ELIZABETH, THE CHURCH OF THE VISITATION, EIN KAREM, ISRAEL

This painting depicts the well in Ein Karem where Mary and Elizabeth met when Mary came to visit.

An angel sent out the birth announcements: Elizabeth was expecting! The exciting news overwhelmed her family and friends and initiated a series of delightful surprises. As Elizabeth whispered her praise to God for the baby she felt so strong and alive inside of her, the Holy Spirit revealed to her the biggest surprise yet: Mary would give birth to God's Son.

Thus Elizabeth exclaimed, "the mother of my Lord" when she saw Mary standing at her doorstep, beaming with excitement. Elizabeth was by now no stranger to the wonder of the impossible, so she believed Mary and rejoiced.

Even though she herself was pregnant with a long-awaited son, Elizabeth could have envied Mary, whose son would be even greater than her own. Instead, she was filled with joy that the mother of her Lord would visit her. Have you ever envied people whom God has apparently singled out for special blessing? A cure for jealousy is to rejoice with them, realizing that God uses his people in ways best suited to his purpose. The next time you feel a twinge of envy toward someone, remember how Elizabeth rejoiced. Make it your aim to enjoy that person's blessing.

Rejoice in good news, wherever you find it.

— NEIL WILSON

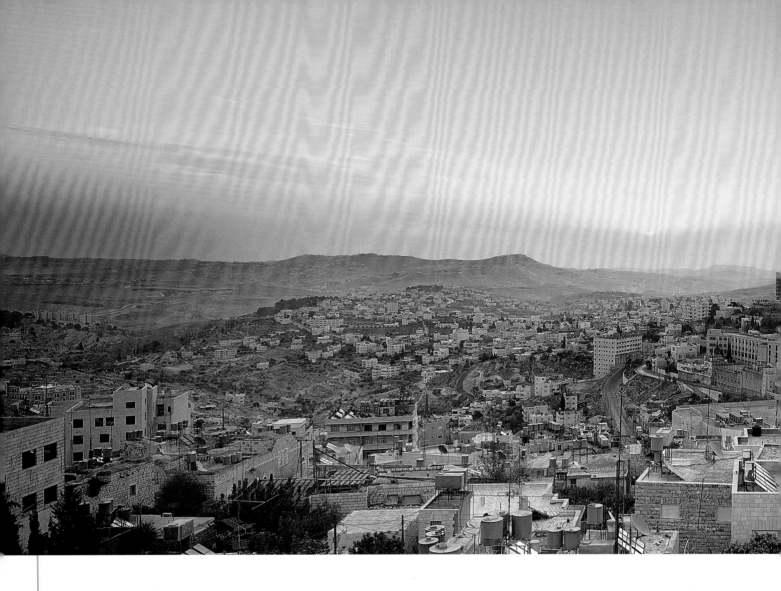

JOSEPH ALSO *went* UP FROM THE TOWN

OF NAZARETH . . . TO BETHLEHEM . . .

TO REGISTER WITH MARY, WHO WAS *pledged*

TO BE MARRIED TO HIM AND WAS

expecting A CHILD.

(LUKE 2:4–5)

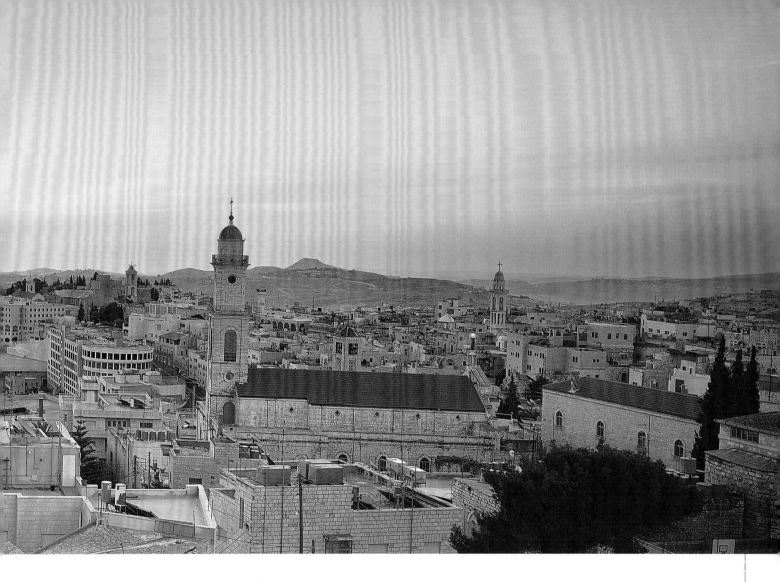

The Romans ruled the civilized world at this time. By contrast, Joseph controlled very little. Against his better judgment and political convictions he complied with the Roman order and traveled with Mary to Bethlehem. Often people feel like Joseph, caught by forces larger than they are. . . .

The government forced Joseph to make a long trip just to pay his taxes. His fiancée, who had to go with him, was going to have a baby any moment. But when they arrived in Bethlehem, they couldn't even find a place to stay. Doing God's will often takes people out of their comfort zones. Jesus' life began in poverty. Later, Jesus would stress to his disciples what it meant to have no place to lay one's head (Luke 9:58). Those who do God's will are not guaranteed comfortable lives. But they are promised that everything, even their discomfort, has meaning in God's plan.

— LIFE APPLICATION BIBLE COMMENTARY—LUKE

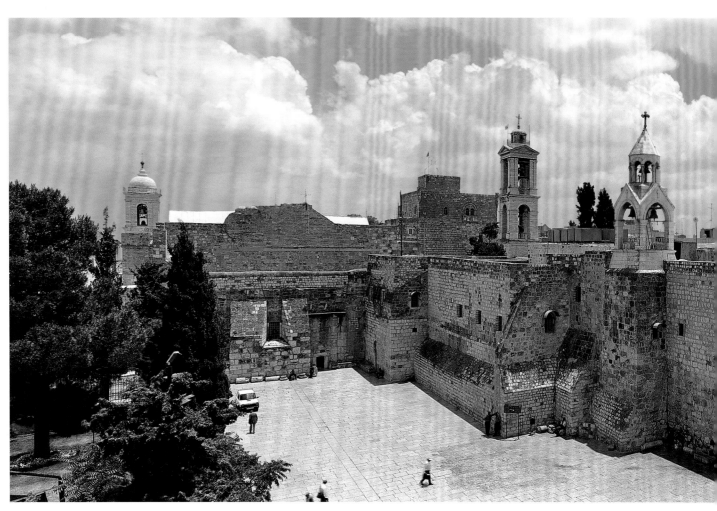

THE CHURCH OF THE NATIVITY, BETHLEHEM, PALESTINE

WHILE THEY WERE THERE,

THE TIME CAME FOR THE *baby* TO BE BORN, AND SHE GAVE

BIRTH TO HER FIRSTBORN, A SON. SHE WRAPPED HIM IN

CLOTHS AND *placed* HIM IN A MANGER, BECAUSE THERE WAS

NO ROOM FOR THEM IN THE INN.

(LUKE 2:6–7)

The birth of the Christ child was a humble event that went unnoticed in the hustle and bustle of Bethlehem. Men bringing their animals to the stable probably did not even give the young family a second glance. The innkeeper who owned the stable probably forgot about Mary and Joseph in his rush to serve his paying customers.

But God knows the hearts of all people. He saw some grubby, lowly shepherds in the fields guarding their flocks of sheep. Like Mary and Joseph, they were commoners whom no one noticed. But they were given the most incredible news that night: The Messiah was born in Bethlehem!

A choir of angels announced the news. At first the shepherds were frightened, but then they accepted the message with joy. They said, "Come on, let's go to Bethlehem! Let's see this wonderful thing that has happened, which the Lord has told us about" (Luke 2:15, NLT). They ran into the village, jostled their way through the crowds, and found the baby in the manger. They were so excited about what they witnessed that they told everyone they met about the birth of the Messiah!

— BILL BRIGHT

THE GROTTO OF THE NATIVITY, THE CHURCH
OF THE NATIVITY, BETHLEHEM, PALESTINE

The silver fourteen-pointed star designates the spot where,
according to tradition, Jesus was born.

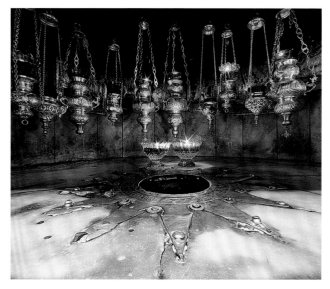

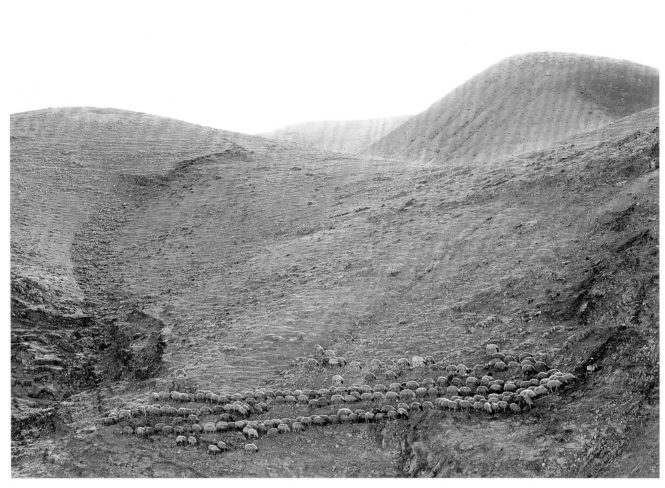

SHEPHERD WITH SHEEP ON A HILLSIDE IN ISRAEL, NOT FAR FROM BETHLEHEM, PALESTINE

"DO NOT BE AFRAID. I BRING YOU GOOD NEWS OF

GREAT JOY THAT WILL BE FOR *all* THE PEOPLE.

TODAY IN THE TOWN OF DAVID A SAVIOR HAS BEEN BORN TO YOU;

HE IS *Christ the Lord.*"

(LUKE 2:10–11)

Does it not seem mysterious that God brought the first message of the birth of Jesus to ordinary people rather than to princes and kings? In this instance, God spoke through his holy angel to the shepherds who were keeping sheep in the fields. This was a lowly occupation, so shepherds were not well educated. But Mary in her song, the *Magnificat*, tells us the true story: "He hath put down the mighty from their seats, and exalted them of low degree. He hath filled the hungry with good things; and the rich he hath sent empty away" (Luke 1:52–53, KJV). What a word for our generation!

What was the message of the angel to the shepherds? First, he told them not to be afraid. . . . When the angel had quieted the fears of the shepherds, he brought this message, one forever to be connected with the evangel: "For, behold, I bring you good tidings of great joy, which shall be to all people. For unto you is born this day in the city of David a Savior, which is Christ the Lord" (Luke 2:10–11, KJV).

—BILLY GRAHAM

ST. THEODOSIOS MONASTERY, EAST OF BETHLEHEM, PALESTINE

The cave under the raised lights in the foreground is said to be where the wise men stayed on their way to see Jesus.

WHEN THE *time* OF THEIR PURIFICATION

ACCORDING TO THE *Law of Moses* HAD BEEN COMPLETED,

JOSEPH AND MARY TOOK [JESUS]

TO JERUSALEM TO *present* HIM TO THE LORD.

(LUKE 2:22)

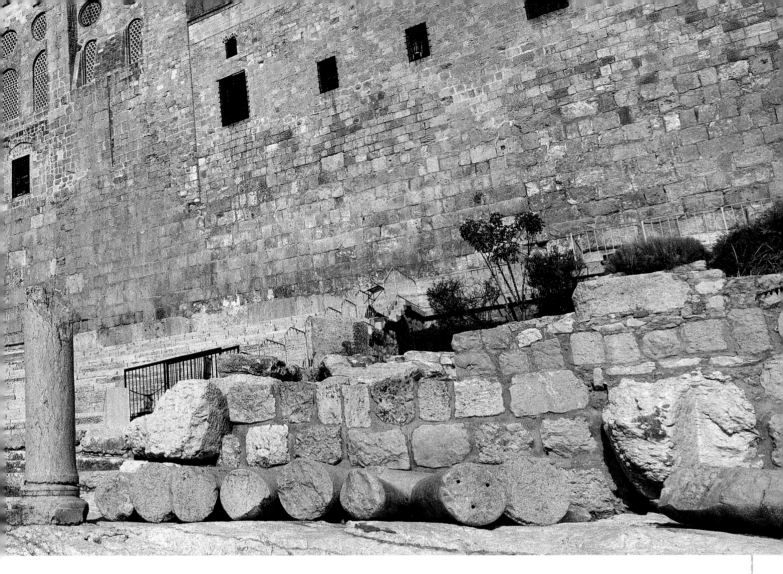

When Mary and Joseph brought the Child Jesus to present him to the Lord, it was not an empty ritualistic ceremony. It was not merely fulfilling the Law of the Lord. For them it was a total oblation of Jesus to the Father and also an oblation of themselves.

Having been formed by the Holy Spirit throughout her tender years, Mary understood the purpose of the coming of Jesus into the world. This presentation was the formal beginning of his life dedicated solely to his Father's will.

At this ceremony Mary also offered herself to God in whatever capacity she could fulfill her role in his divine plan. Simeon prepared Mary for her role: "A sword will pierce your own soul too" (Luke 2:35).

Each day Mary committed herself anew to God's plan. Mary did not yet know about the exile into Egypt, the poverty of Nazareth, nor what Calvary had in store for her.

What joy must have filled her heart, nonetheless, since she was privileged to present her Son to a world awaiting redemption!

— DAVID E. ROSAGE

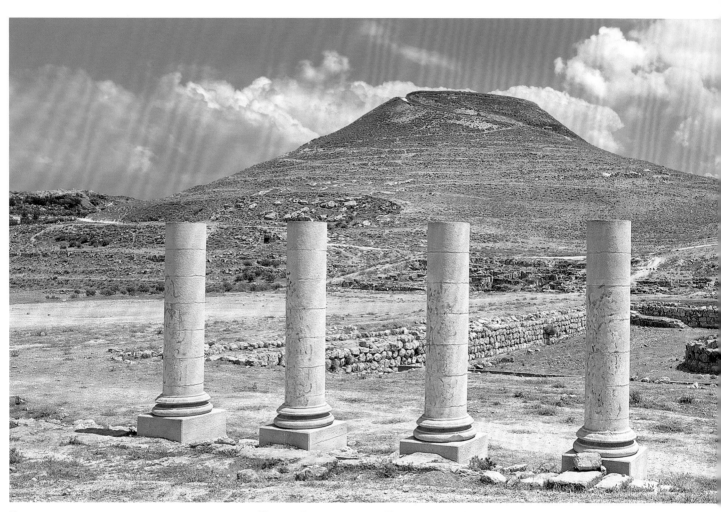

THE ANCIENT BATH HOUSE IN ONE OF HEROD'S PALACES, HERODION, PALESTINE

This is the site of one of Herod's opulent palaces and where he was buried.

DURING THE TIME OF *King Herod,* MAGI FROM THE EAST

CAME TO JERUSALEM AND ASKED,

"WHERE IS THE ONE WHO HAS BEEN BORN *king* OF THE JEWS?

WE SAW HIS STAR IN THE EAST AND HAVE COME TO WORSHIP HIM."

(MATTHEW 2:1–2)

The wise men struggled to continue believing the words of the prophets when they were led to such an inappropriate setting for a royal birth. God comforted and strengthened them with the star. It was closer to them now than it was at the beginning. It guided them. When they started out, it was far away from them, and they didn't know where they would find the king. . . .

Our foolish nature often feels this way when trying to follow God's words. Since the wise men became so happy when they saw the star, we can infer that they faced these doubts and were deeply depressed. Their joy indicates that their hearts had been greatly disturbed. They struggled with their doubts, and there was certainly enough reason for doubt in this situation. So Christ really means it when he says, "Whoever doesn't lose his faith in me is indeed blessed" (Matthew 11:6, GW).

— MARTIN LUTHER

THE CHAPEL OF THE INNOCENTS,
BETHLEHEM, PALESTINE

These are the bones of some of the children who were murdered as a result of Herod's decree.

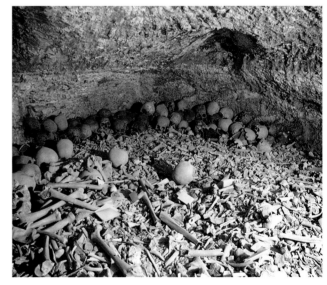

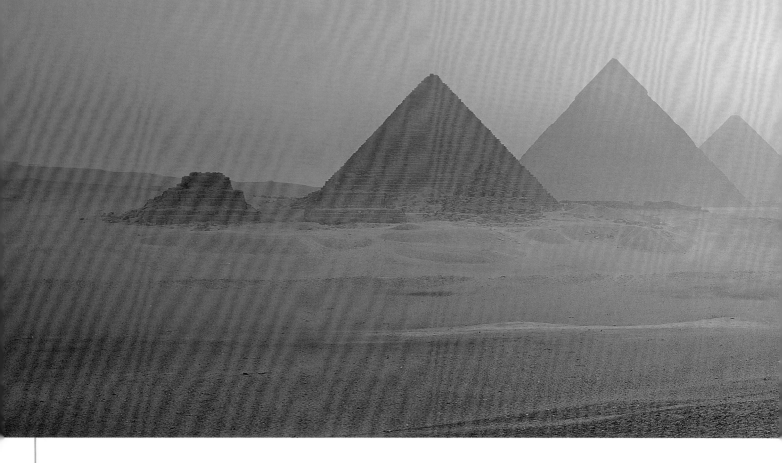

AN *angel* OF THE LORD APPEARED TO JOSEPH IN A DREAM.
"GET UP," HE SAID, "TAKE THE CHILD AND HIS
MOTHER AND *escape* TO EGYPT."

(MATTHEW 2:13)

A small incident in the Christmas story, usually overlooked and seldom portrayed in church pageants, looms large in the salvation narrative. Occurring immediately after what often is presented as the climax of the story—the visit of the Magi—Joseph has another nighttime encounter with an angel. This time, God's messenger tells him to flee with his family to Egypt. They had just entertained Eastern celebrities bearing fabulous gifts for their child-king. Now, abruptly, they are to run for their lives. And the destination—Egypt.

The phrase "out of Egypt" appears in nearly 150 biblical texts. This ancient enemy symbolized oppression and slavery, and often God's people would recall that the Lord had freed them and delivered them from that place. Yet God says, "Go to Egypt." What is Joseph thinking and feeling? His first encounter with an angel announced a "virgin" birth. Then, the baby, born in a stable, was visited by shepherds and kings. And now, this!

We don't know Joseph's thoughts, but we do know his actions. He obeyed. And Jesus escaped Herod's murderous wrath. And we celebrate Christmas.

"But," we protest, "we'd obey too if we knew God was talking!" Really? He speaks to us daily, but do we listen? Unlike Joseph, we have God's written Word, filled with direction and instruction. May we, with Joseph-like faith, obey and get moving.

—DAVE VEERMAN

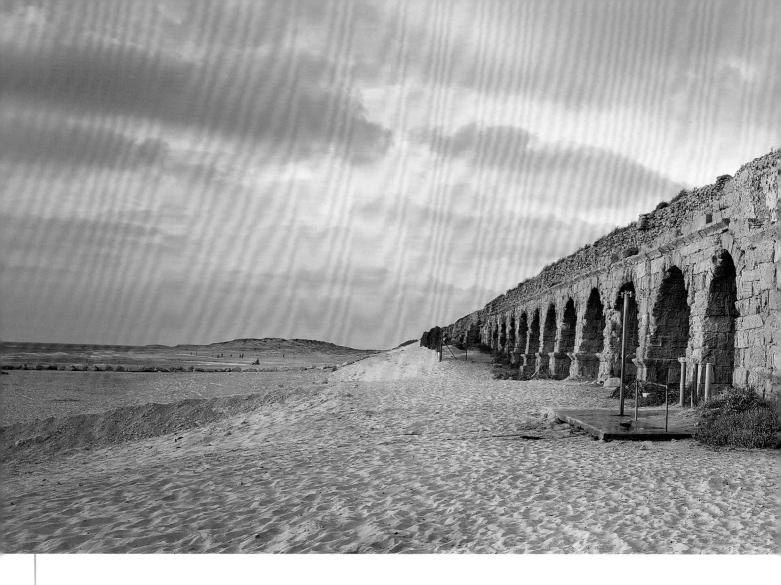

AFTER HEROD DIED, AN ANGEL OF THE LORD *appeared* IN A

DREAM TO JOSEPH IN EGYPT AND SAID,

"GET UP, *take* THE CHILD AND HIS MOTHER AND GO TO THE

LAND OF ISRAEL, FOR THOSE WHO WERE TRYING

TO TAKE THE CHILD'S *life* ARE DEAD."

(MATTHEW 2:19–20)

*On returning to Nazareth, Mary, Joseph, and Jesus
would have passed this way along the coastal road.*

After some time has elapsed, Joseph learns that Herod has died and that it is now safe for the family to return to the land of Israel. . . .

As in previous episodes, Joseph responds obediently to God's command and takes his family back to Israel. Joseph assumes, initially, that he is returning to the home he left in Judea. Further revelation, however, convinces him that the political climate in Judea is still too risky. . . .

Where Christian believers still must flee the terror of hostile powers, the force of Matthew's story will be readily felt. For them it brings the assurance that God's deliverer knows their uprooted condition and runs with them in their flight. For others of us, however, it is difficult to identify with the way of the refugee. We have never had to seek a more hospitable city or country. How does Matthew's story speak to us? At least, it is a reminder that the comfortable, settled life we now live is a precarious blessing, subject to disruption at any moment. Beyond that, it is an invitation to express our solidarity with those who are refugees and to welcome them into our midst. When we do so, we confirm our kinship with the refugee of Bethlehem, Jesus the Christ.

—RICHARD B. GARDNER

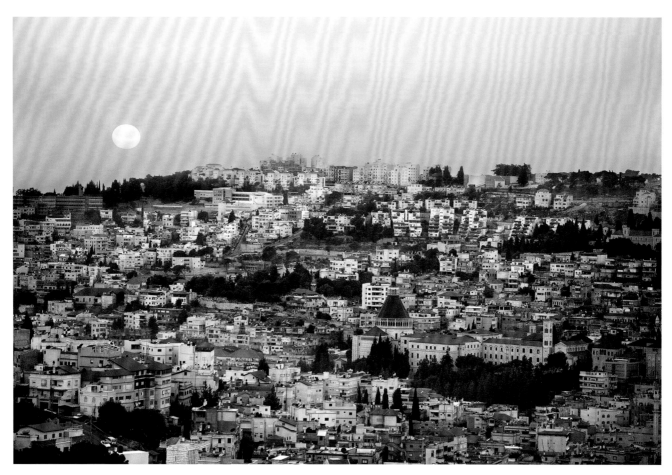

SUNSET OVER NAZARETH, ISRAEL

THEY *returned* TO GALILEE TO

THEIR OWN TOWN OF NAZARETH.

AND THE CHILD *grew* AND BECAME STRONG.

(LUKE 2:39-40)

The village of Nazareth was quite insignificant. It is not mentioned with other cities in the ancient records of writers. We recall Nathanael's reply of incredulity when Philip told him that the Messiah had come from Nazareth, "Can anything good come from there?" (John 1:46). Thus was Nazareth thought of and spoken of with contempt. That is, until Jesus changed all that.

In this somewhat obscure village, Jesus grew up. There were brothers and sisters in the home. Jesus played the older brother's part.

Christ as the Nazarene lived in a humble home, did the manual work of a carpenter, and mingled in the busy mart and everyday life of the people. There are many to whom this warm portrait of the Master gives comfort and reassurance. . . .

Nazareth was just a hamlet, obscure and insignificant until Jesus came and made his home there. His presence has a transforming influence on all that comes in close contact with him. So, too, if we will invite him to come and make his abode in our lives, he will transform our common lives to ones with eternal meaning and purpose.

—HENRY GARIEPY

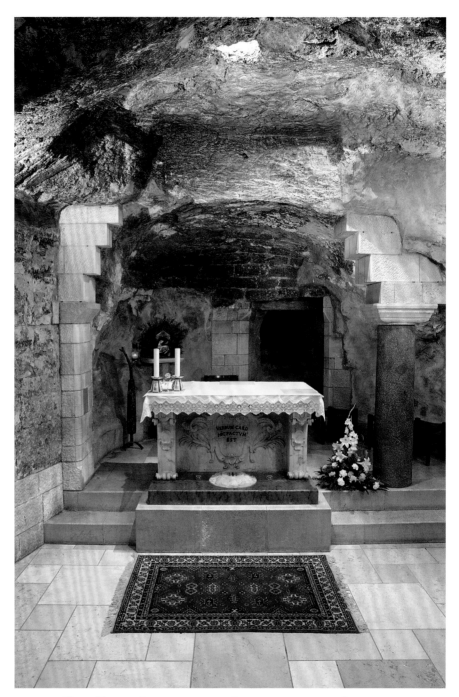

THE HOLY GROTTO, THE CHURCH OF THE ANNUNCIATION, NAZARETH, ISRAEL

This church is built over the Holy Grotto, where it is said the angel Gabriel appeared to Mary. It is also believed this is where Mary, Joseph, and Jesus lived on their return to Nazareth.

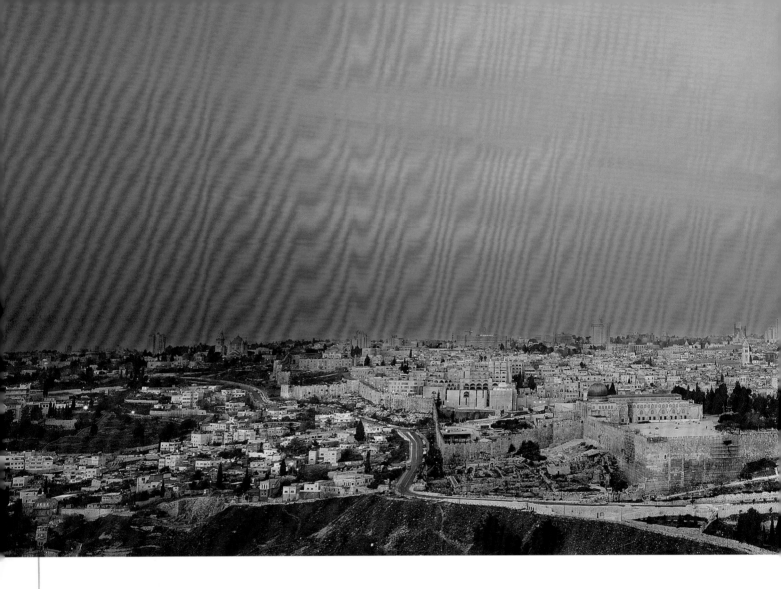

EVERYONE WHO HEARD HIM WAS *amazed*

AT HIS *understanding* AND HIS ANSWERS.

(LUKE 2:47)

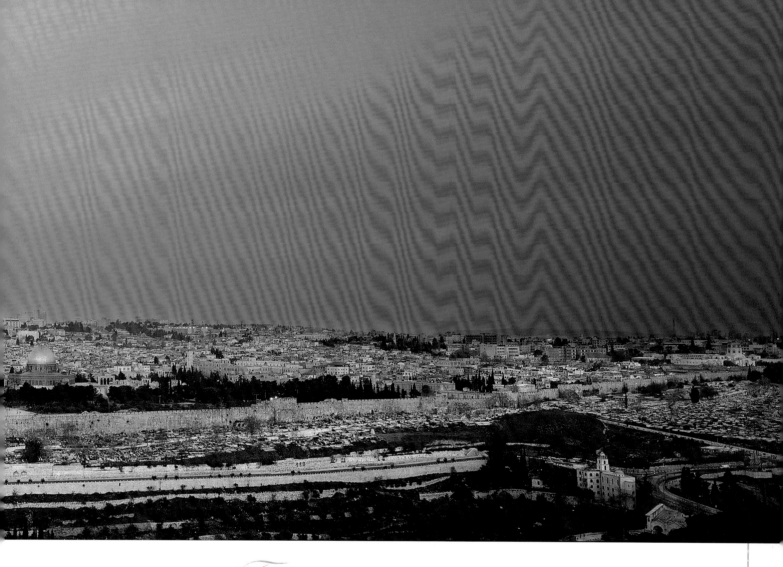

SUNRISE OVER JERUSALEM, ISRAEL

Two facts are before us. By theological necessity and physical description, Jesus had to be fully human. Ancient heresies that reduced his humanity and inflated his divinity have been refuted by revelation and reason. Modern critics have fared no better. To strip Jesus of his deity makes him a liar, not a brother. The biblical alternative is to accept the essential truth that Jesus, the Son of God, was a real, complete human being.

Whatever the gaps of theology and history in the life of Jesus, God's purpose is no mystery. He gave us a compassionate man who understands us and an obedient man who redeems us. Only the incarnate Christ can explain the response of my friend who was grieving the loss of his daughter in a flash flood along the Thompson River in Colorado. When I met him two weeks after the tragedy, his eyes were sunk in dark sockets from weeping. Awkwardly, I asked, "How is it going?"

Never given to public testimony or eloquent statements, his sad eyes looked back, and he spoke almost from a trance, "The hurt goes deep, but his love goes deeper."

—DAVID L. MCKENNA

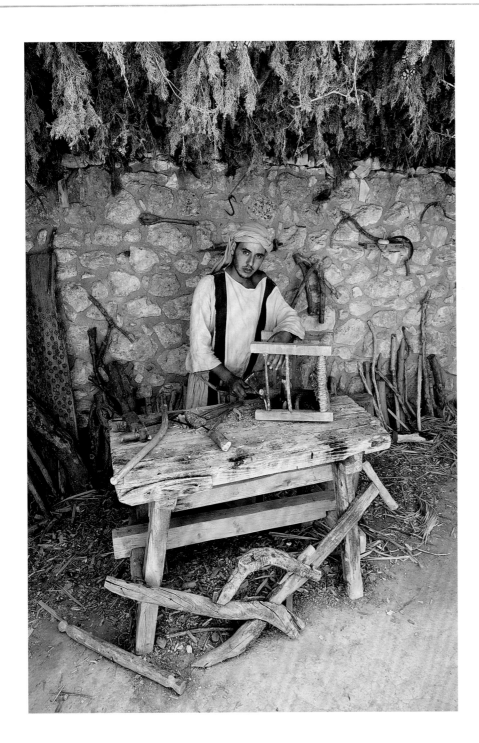

AND JESUS GREW IN *wisdom* AND STATURE, AND IN *favor* WITH GOD AND MEN.

(LUKE 2:52)

OLD CARPENTRY WORKSHOP, NAZARETH, ISRAEL

Nazareth Village has been reconstructed to show how it appeared at the time of Christ.

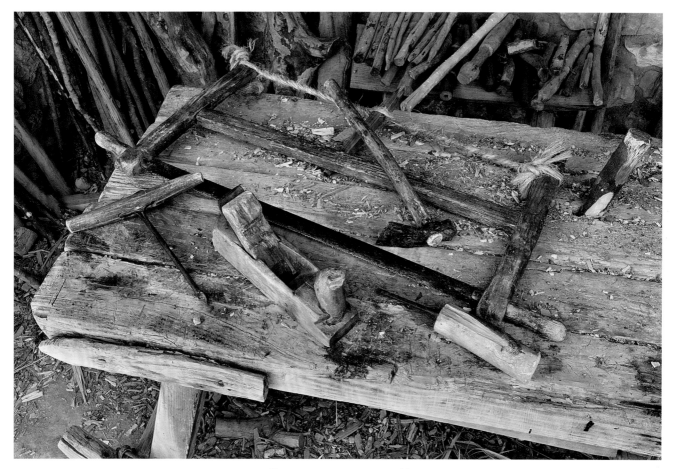

Let's wonder together what Christ was like as a child. . . .

Matthew 13:54–58 tells of Jesus' rejection by the people of his hometown. They considered him too ordinary to be worthy of their attention. These verses remind us that Christ grasped average humanity by experiencing it. He grew up in a small town with parents who possessed little wealth but came to be rich in offspring. . . .

Certainly Jesus was reared according to Jewish law and tradition. Joseph took a primary role in his religious upbringing. Jesus read Scripture by the time he was five. At six he probably attended the school of the local rabbi. While still quite young, Christ began memorizing lengthy Scripture passages. . . .

Jesus was a little boy, a human little boy, with a little boy's childhood. But consider what made his childhood unique—the "otherness" of Christ. One of Mary and Joseph's children was God incarnate. The rest were not. Can you imagine calling the Son of God for supper? Or telling him to wash his hands? If you knew one of your children was the divinely born Son of God, would you want to be certain he ate his vegetables? How in the world would earthly parents rear the perfect Son of God in an imperfect household?

—BETH MOORE

PAINTING OF JESUS' WATER INTO WINE MIRACLE, THE FRANCISCAN CHURCH,
KFAR KANA (CANA), ISRAEL

Beginnings

People often take journeys to find themselves. Jesus journeyed to find us. Those who were paying attention heard him express his purpose in several ways:

"And I, the Son of Man, have come to seek and save those like him who are lost" (Luke 19:10, NLT).

"My nourishment comes from doing the will of God, who sent me, and from finishing his work" (John 4:34, NLT).

Jesus' walk was a working journey. He knew his own identity. He understood his reason for being here. Jesus embarked upon a search and rescue mission when he came to earth. We were the lost ones. He found people like us everywhere he went. But he started in a somewhat unexpected place—a wedding in Cana of Galilee.

Those who walk with Jesus become those who work with him. Those who refuse to work with him find they can't walk with him either. Until we are sure, however, Jesus walks through our lives, just as he walked through the first disciples' lives. He catches our attention, and says, "Follow me."

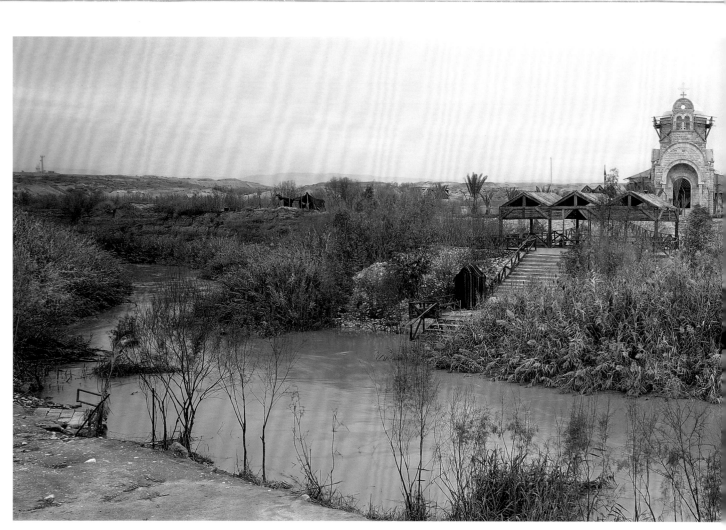

JESUS' BAPTISM SITE, JORDAN RIVER, KASR EL YEHUD, ISRAEL

In Jesus' day, the Jordan River was wider and had a greater flow of water.

AT THAT TIME *Jesus* CAME FROM NAZARETH IN GALILEE

AND WAS *baptized* BY JOHN IN THE JORDAN.

(MARK 1:9)

John was calling Israel to acknowledge God's judgment on Israel. Passing through the waters of the promise again, a new, forgiven Israel would emerge. When Jesus comes to John for baptism, therefore, he is consenting to this calling of Israel. He is not seeking salvation for himself or fleeing from the wrath to come; rather, he is joining in the renewal of Israel and in the march of God's unfolding purpose for the world. . . . His baptism, therefore, launches him on the servant road of obedience, which ultimately leads to his death (Mark 10:38).

In Jesus' baptism, we also glimpse the mysterious balance between the human and the more-than-human Jesus. The thundering approval from heaven discloses Jesus' divine identity, but it is linked to his humble subjection to human conditions. Jesus does not come as a powerful, conquering Messiah, an irresistible force, but as a submissive Messiah, who yields in obedience to the baptism of John. . . . The kingdom of God does not come with sirens blaring and bombs bursting in air, but quietly and inconspicuously.

—DAVID E. GARLAND

THE JORDAN RIVER NEAR THE SEA OF GALILEE, ISRAEL

Here the Jordan River leaves the Sea of Galilee on its journey to the Dead Sea. This area is still very much the same as it was in the time of Christ.

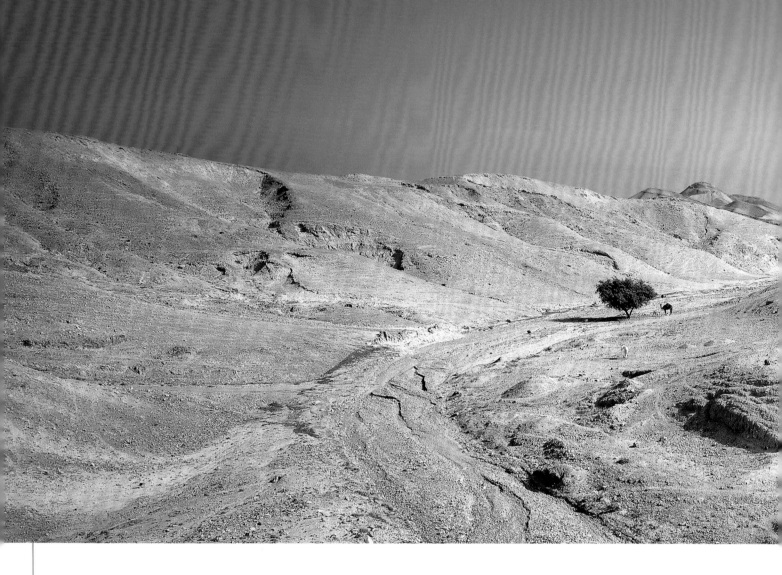

AT ONCE THE *Spirit* SENT HIM OUT INTO THE DESERT,

AND HE WAS IN THE *desert* FORTY DAYS,

BEING *tempted* BY SATAN.

(MARK 1 : 12 – 13)

We find a strange and deceptive comfort in imagining that Satan would draw the line at certain limits and act appropriately. For instance, we mistakenly assume that surely Satan would leave us alone in our heart-rending grief because, after all, he knows we're defenseless and weak. Wrong. . . . Luke 4:13 concludes the record of Christ's temptation with the harrowing words: "When the devil had finished all this tempting, he left him until an *opportune* time" (emphasis mine). Where was the devil when Christ was in Gethsemane, grieving and pouring sweat-drops of blood? Putting his final touches on the trap he had set up through his puppet, Judas (Luke 22:3–6). . . .

We are very wise to muster the energy to take these protective measures:
- *pray for protection through our season of grief*
- *pray for healthy grief*
- *surrender our grief to God so Satan can't get a foothold*
- *call on warring intercessors to pray for us in our weakness*
- *keep lines of communication open with God even when all we can say is "Help!" or "Why?"*
- *believe God's Word that tells us He can and will restore abundant life . . . if we'll let Him.*

—BETH MOORE

THE JUDEAN WILDERNESS, ISRAEL
Jesus was led into the Judean wilderness to be tempted.

AFTER *fasting* FORTY DAYS AND FORTY NIGHTS,

HE WAS HUNGRY. THE *tempter* CAME TO HIM AND SAID,

"IF YOU *are* THE SON OF GOD,

TELL THESE *stones* TO BECOME BREAD."

(MATTHEW 4:2–3)

**THE MOUNT OF TEMPTATION,
NEAR JERICHO, PALESTINE**

When was the last time you looked for Jesus in the midst of a pressing temptation? Our problem is that we haven't known he is there! Most of the time we try to break the spell of sin on our own power by learning to fear the consequences, by trying to "buck up" and be good, by finding an accountability partner, or by a dozen other good but inadequate mechanisms.

But only he can deliver you.

Temptation is not foreign to him. In the wilderness, exhausted and hungry from an extended fast, the King of creation went one-on-one with the great seducer. Jesus is no stranger to our struggles. Which is precisely why Scripture reminds us that he was tempted in every way like we are. He understands and promises to give us grace and mercy to help in our time of need (Hebrews 4:14–16).

—JOSEPH M. STOWELL

VIEW FROM THE MOUNT OF TEMPTATION, JERICHO, PALESTINE

This is called the Mount of Temptation, thought to be where Satan took Jesus and showed him the kingdoms of the world.

THEN THE DEVIL TOOK HIM TO THE *holy* CITY

AND HAD HIM *stand* ON THE HIGHEST POINT OF THE TEMPLE.

"IF *you* ARE THE SON OF GOD," HE SAID,

"THROW *yourself* DOWN."

(MATTHEW 4:5–6)

The rabbis had all sorts of expectations about the messianic kingdom. One of them ran like this. "When King Messiah comes, he will stand upon the roof of the holy place. Then he will announce to Israel, 'Ye poor, the time of your redemption draws nigh.'" The rabbis were also sure that when Messiah came there would be a repetition of the gift of manna in the desert. That is why the Jews got so excited when Jesus fed the multitude in a desert place. That is why they tried to make him king. . . . What temptations to bypass the cross, to short-circuit the path of obedience, and to adopt the role of the Son and the King without stooping to the role of the suffering Servant! . . . To be sure, the temptations to be selfish, to opt for the sensational and to compromise come the way of all Christians, but they are recorded here so that we may witness the testing of God's Son. Is his messiahship to be the slave of popular expectation? Or will he go to the cross to win the crown?

— MICHAEL GREEN

TEMPLE PINNACLE, JERUSALEM, ISRAEL

The pinnacle of the Temple, possible site of Jesus' second temptation.

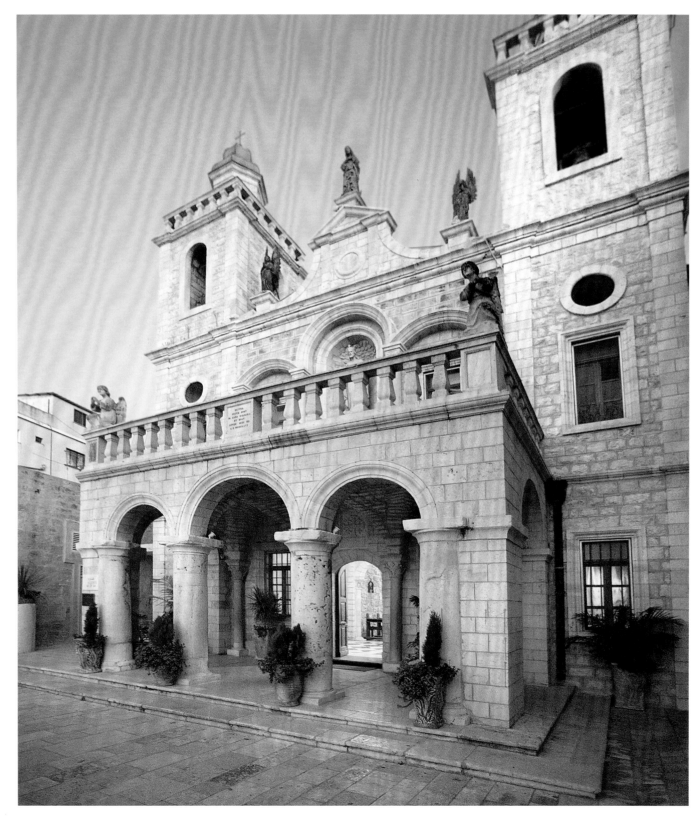

JESUS SAID TO THE SERVANTS, "FILL THE JARS WITH WATER";
SO THEY *filled* THEM TO THE BRIM.

THIS, THE FIRST OF HIS MIRACULOUS SIGNS,
JESUS *performed* IN CANA OF GALILEE.

(JOHN 2:7, 11)

What we have in the Gospel of John, shown dramatically at the wedding in Cana, is that what Jesus says and what he does are an inseparable whole. . . . Jesus in the Gospel of John is the Word who becomes flesh. What is love, then, in the Gospel of John? It is the event where Jesus welcomes Andrew and John to spend the day with him to ask their questions; it is Jesus caring about really knowing Nathanael; it is Jesus caring for the embarrassment of a bridegroom at a wedding; it is Jesus, moved deeply by the despair of a city official whose son is dying, healing the son. These are events, and these are what love is in the New Testament. Love in the New Testament is not external theory or concept but the inseparable mixture of word and event. These events are not illustrations of love, they are the very reality itself. . . .

Jesus Christ does not need the church to make his character concrete and exciting. He speaks for himself.

—EARL F. PALMER

THE GREEK ORTHODOX CHURCH, CANA, ISRAEL *(left)*

STONE VESSEL *(inset)*

*This church has two of the stone vessels believed to be used
in the miracle of changing water into wine.*

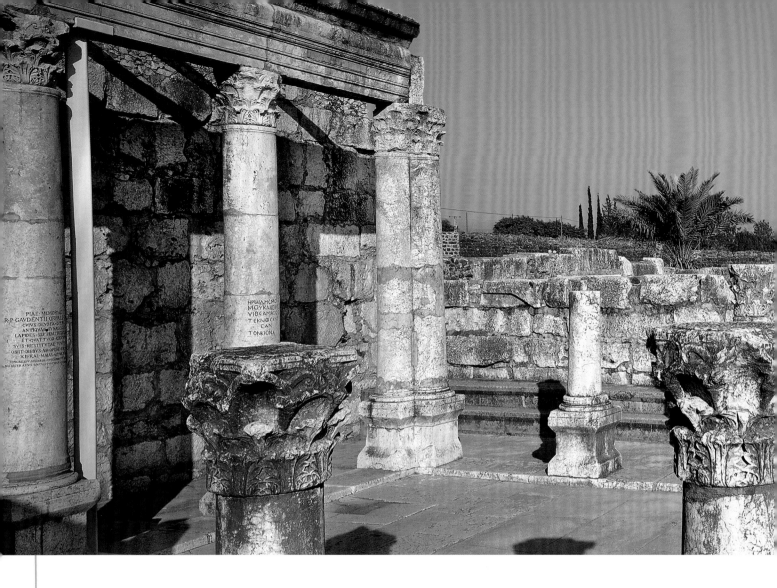

WHEN JESUS *heard* THAT JOHN HAD BEEN PUT IN PRISON,

HE RETURNED TO GALILEE. LEAVING NAZARETH,

HE WENT AND *lived* IN CAPERNAUM.

(MATTHEW 4 : 12 – 13)

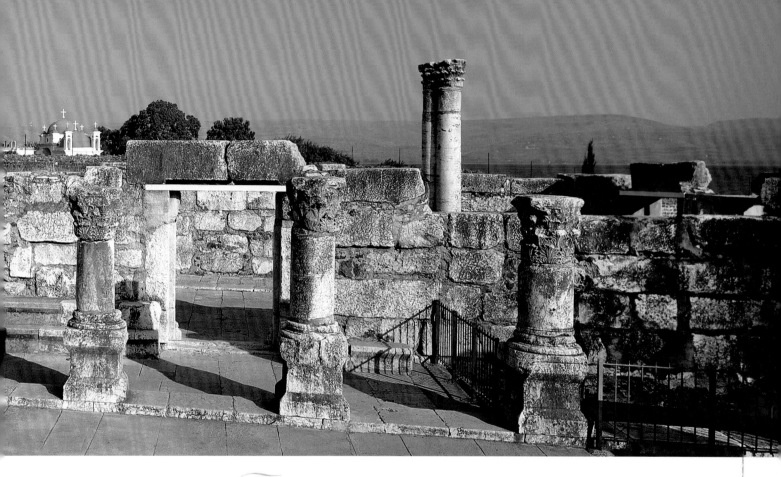

SYNAGOGUE, CAPERNAUM, ISRAEL

Jesus lived in Capernaum for a time and used it as his base. From this place he traveled throughout Galilee. Jesus also taught in a synagogue in Capernaum.

The first answer given the first doubter is the only one necessary.

When Nathanael doubted that anything good could come out of Nazareth, Philip's response was simply, "Come and see." . . .

Come and see the pierced hand of God touch the most common heart, wipe the tear from the wrinkled face, and forgive the ugliest sin.

Come and see.

Come and see the tomb. The tomb once occupied, now vacant; the grave once sealed, now empty. Cynics have raised their theories, doubters have raised their questions. But their musings continue to melt in the bright light of Easter morning.

Come and see. He avoids no seeker. He ignores no probe. He fears no search. Come and see. Nathanael came. And Nathanael saw. And Nathanael discovered, "Teacher, you are the Son of God; you are the King of Israel" (John 1:49, NCV).

—MAX LUCADO

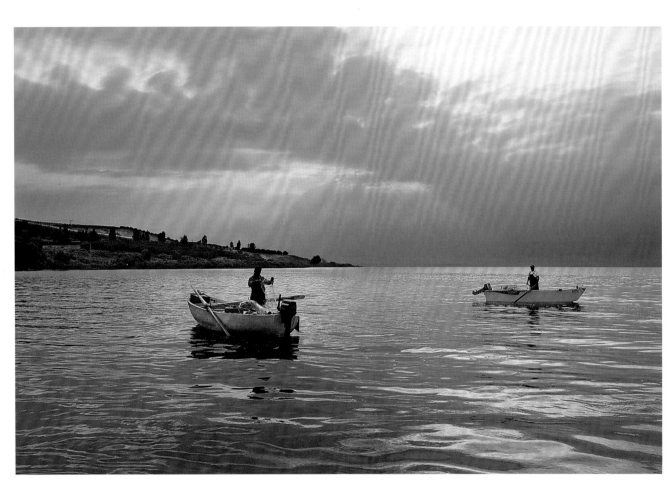

Two fishermen, Sea of Galilee, Israel

"Come, follow me," Jesus said,

"and I will make you *fishers* of men."

At once they left their nets and followed him.

(Matthew 4:19–20)

Jesus' followers were, in today's language, small businessmen, working as families not for huge profits but to make enough to live on and have a little over. Fish were plentiful and there were good markets. In a cosmopolitan area, with soldiers, wayfarers, pilgrims, and peddlers coming and going, as well as the local population, people would always want what they were selling. But it was hard work, and sometimes dangerous. Their lives were modestly secure, but hardly luxurious.

So why did they give it all up to follow a wandering preacher? . . .

The answer can only be in Jesus himself, and in the astonishing magnetism of his presence and personality. This can be known and felt today, as we meditate on the stories about him and pray to know him better, just as the first disciples knew and felt his presence 2,000 years ago. . . . When that happens to you, by whatever means and at whatever place, you will know; Jesus has a way of getting through, and whatever we are engaged with— whatever nets we are mending, or fish we are catching—somehow we will be sufficiently aware of his presence and call to know what it is we're being asked to do.

—TOM WRIGHT

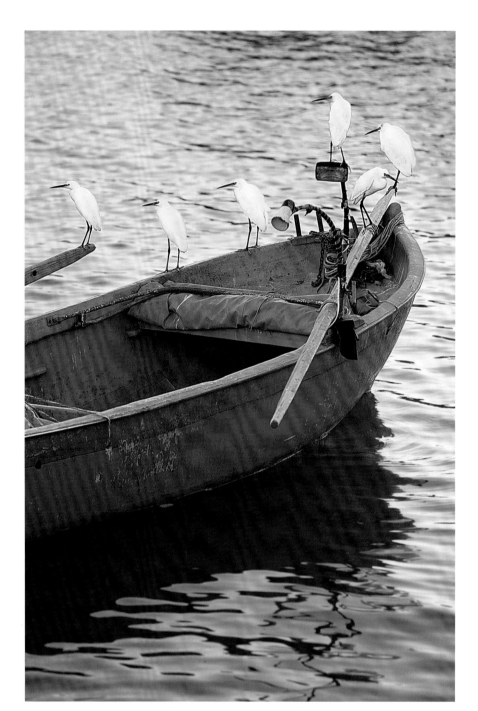

BIRDS ON A BOAT, SEA OF GALILEE, ISRAEL

JACOB'S WELL, SYCHAR, SAMARIA (NABLUS, PALESTINE)

In Nablus (the biblical city of Sychar) is the well of Jacob, dug by the patriarch over 3,000 years ago. Here Jesus met the woman from Samaria.
This has been considered a holy place from early in the fourth century when a church was built over the well. The water is as fresh and clear today as in Jesus' day.

JACOB'S WELL WAS THERE, AND JESUS,

TIRED AS HE WAS *from* THE JOURNEY,

SAT DOWN BY THE WELL.

IT WAS ABOUT THE *sixth* HOUR.

(JOHN 4:6)

Where Jesus Walked

She had two strikes against her already: (1) She was a Samaritan, not a Jew, and (2) she was a woman, of all things. John, the only gospel writer to record this story, didn't even include her name.

Non-Jew, non-male, who cares?

Jesus cared.

Jesus said to her, "Will you give me a drink?" (John 4:7)

He cared so much he spoke to her directly. No doubt he looked her in the eyes when he said it, might even have touched the sleeve of her garment to get her attention.

Oh, it gives me shivers just to *think* of it! The Lord reaching out to someone who was in all ways a social reject. Notice he didn't command her; he asked her. His words were polite and forthright, the start of a lengthy conversation—the longest found in Scripture between Jesus and anyone, let alone a Samaritan.

Let alone a woman.

Let alone *that* kind of woman.

Her gender and her nationality are not incidental to the story; they are integral because they drive home the universal truth of God's fountain of grace: Its refreshing waters are meant for every human being willing to hold out his empty cup.

—Liz Curtis Higgs

WATER JAR FROM THE TIME OF CHRIST

JESUS ANSWERED HER,

"IF YOU KNEW THE *gift* OF GOD AND WHO IT IS THAT ASKS

YOU FOR A DRINK, YOU WOULD HAVE ASKED HIM AND HE

WOULD HAVE GIVEN YOU *living* WATER."

(JOHN 4:10)

THE CHURCH OF JACOB'S WELL,
SYCHAR, SAMARIA
(NABLUS, PALESTINE)

For seven centuries there had been rivalry, often fierce and bitter, between the Jews and the Samaritans. One of the chief points at issue, theologically speaking, was the correct place at which to worship. As the woman said to Jesus by the well-side: "Our fathers worshiped on this mountain. . . ." Jesus replied: "Woman, believe me, the hour is coming when neither on this mountain nor in Jerusalem will you worship the Father. . . . the true worshipers will worship the Father in spirit and truth, for the Father is seeking such people to worship him. God is spirit, and those who worship him must worship in spirit and truth" (John 4:20, 21, 23, 24 ESV).

With these words Jesus taught that the nature of our worship must accord with the nature of the God we are worshiping. If it is the rational worship of a rational God, it is also the spiritual worship of a spiritual God. . . . Because God is spirit, our worship of him is not tied to, or dependent on, any particular place or form. In essence, the worship pleasing to God is inward not outward, the praise of the heart not the lips, spiritual not ceremonial.

—JOHN R. W. STOTT

"AND NO ONE POUR NEW WINE INTO OLD *wineskins*.

IF HE DOES, THE WINE WILL BURST THE SKINS,

AND *both* THE WINE AND THE WINESKINS

WILL BE RUINED."

(MARK 2:22)

Every age knows the temptations to forget that the gospel is ever new. We try to contain the new wine of the gospel in old wineskins—outmoded traditions, obsolete philosophies, creaking traditions, old habits. But with time the old wineskins begin to bind the gospel. Then they must burst, and the power of the gospel pour forth once more. Many times this has happened in the history of the church. Human nature wants to conserve, but the divine nature is to renew. It seems almost a law that things initially created to aid the gospel eventually become obstacles—old wineskins. Then God has to destroy or abandon them so that the gospel wine can renew man's world once again.

The gospel is new in our day. It is still "the power of God." It is still bursting old wineskins and flowing forth into the world. . . .

But there is something else this parable teaches us—the necessity of new wineskins. Wineskins are not eternal. As time passes they must be replaced—not because the gospel changes, but because the gospel itself demands and produces change! New wine must be put into new wineskins—not once-for-all, but repeatedly, periodically.

—HOWARD A. SNYDER

REPLICA OF A WEAVER'S LOOM

From the time of Jesus, Nazareth Village, Nazareth, Israel
The Decapolis city most likely Jesus would have seen after his Miracle.

"DO YOU NOT SAY, 'FOUR MONTHS MORE AND
THEN THE HARVEST'? I *tell* YOU,
OPEN YOUR EYES AND LOOK AT THE FIELDS!
THEY ARE *ripe* FOR HARVEST."

(JOHN 4:35)

The Good Shepherd protects his sheep against the wolf, and instead of fleeing he gives his life for the sheep. He knows them all by name and loves them. He knows their distress and their weakness. He heals the wounded, gives drink to the thirsty, sets upright the falling, and leads them gently, not sternly, to pasture. . . .

From the human point of view everything looks hopeless, but Jesus sees things with different eyes. Instead of the people maltreated, wretched and poor, he sees the ripe harvest field of God. "The harvest is plentiful" (Luke 10:2). It is ripe enough to be gathered into the barns. . . .

There is now no time to lose: the work of harvest brooks no delay. "But the workers are few." It is hardly surprising that so few are granted to see things with the pitying eyes of Jesus, for only those who share the love of his heart have been given eyes to see. And only they can enter the harvest field.

—DIETRICH BONHOEFFER

FIELDS OF WHEAT, GOLAN HEIGHTS *(left)*

BOY WITH WHEAT SHEAVES *(inset)*

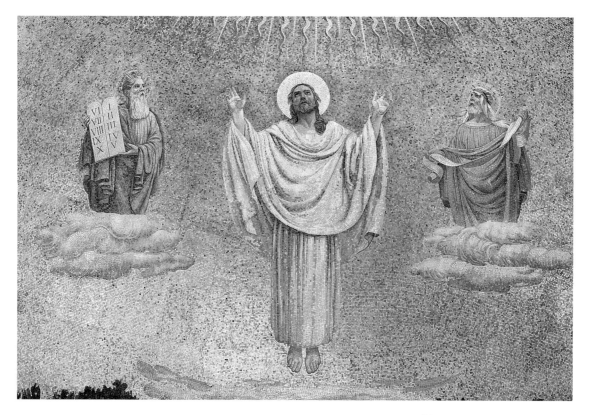

MOSAIC AT MT. TABOR

Crowds and Conflicts

The short years of Jesus' ministry featured a continual ebb and flow of popularity and animosity. At first, his charismatic presence attracted curious and adoring crowds. The rising tide of popularity seemed unstoppable. Those who opposed Jesus didn't fear him; they feared the crowds. But there was always an undertow of doubt, fear, jealousy, and disagreement over his identity and power. Today's adoring crowd may turn into tomorrow's lynch mob.

Early in Jesus' public ministry, the fickleness of fame displayed itself when he visited his hometown of Nazareth. Luke 4:14–30 describes the encounter. In the synagogue, Jesus read a passage from the scroll of Isaiah and applied the message to himself. He soon realized that people weren't listening very carefully. They found his words interesting, but not compelling. They wanted some miracles for entertainment, as any good son of the community ought to provide.

Jesus confronted their assumptions and shattered their feelings of privilege. Within moments the crowd's emotion had turned to a murderous rage. The one miracle Jesus worked in Nazareth that day was to walk away unharmed by the mob to continue his ministry until the time of his suffering would arrive.

[AFTER READING,] HE *rolled* UP THE SCROLL,

GAVE IT BACK TO THE ATTENDANT AND SAT DOWN.

THE EYES OF *everyone* IN THE SYNAGOGUE WERE FASTENED ON HIM,

AND HE BEGAN BY SAYING TO THEM,

"TODAY THIS *scripture* IS FULFILLED IN YOUR HEARING."

(LUKE 4:20–21)

They refused the only absolutely foolproof way the Jews in the synagogue (or anyone else) could have known Jesus was the Messiah, and it had nothing to do with miracles or healing people. They could, very simply, have admitted their sin, asked him to save them, and seen whether or not they experienced the joyous blessing and clearing of conscience that comes to those who repent. They had no intention of doing that, and Jesus knew it. . . .

They tried to murder him, but it wasn't in their power, because it wasn't God's way or his time. Luke 4:30 describes a supernatural, instant calm: "Then passing through the midst of them, He went His way" (NKJV). We don't know how that happened. In some miraculous way, he just was gone. Here was the miracle they had demanded, but it took him from their midst, symbolizing the judgment they brought on themselves by their hateful unbelief. How sad. What might have been for them—forgiveness and fullness of joy forever—they refused.

—JOHN MACARTHUR

THE MOUNT OF THE PRECIPICE,
NEAR NAZARETH, ISRAEL

Jesus enraged some of the inhabitants of Nazareth by his preaching. They tried to throw him off of this precipice to kill him, but Jesus was supernaturally delivered from this fate.

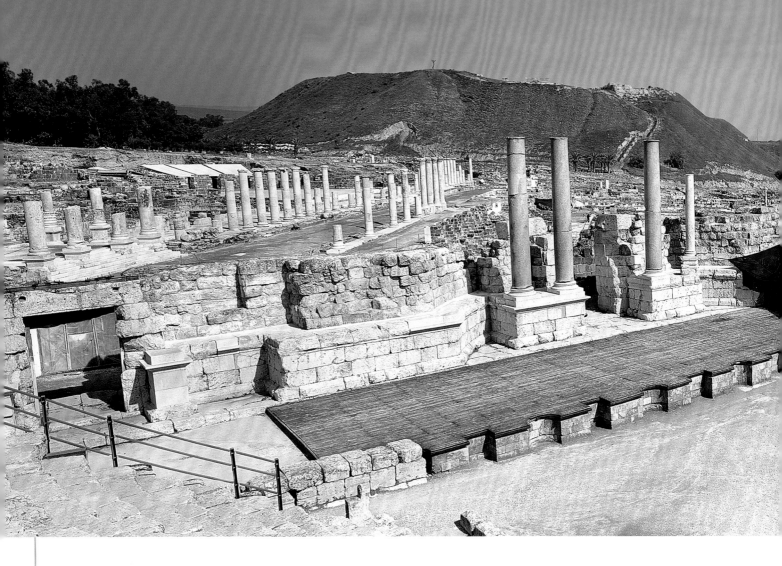

THEN *He* WENT DOWN TO CAPERNAUM,

A TOWN IN GALILEE, AND ON THE SABBATH

BEGAN TO TEACH THE *people.*

(LUKE 4:31)

Where Jesus Walked

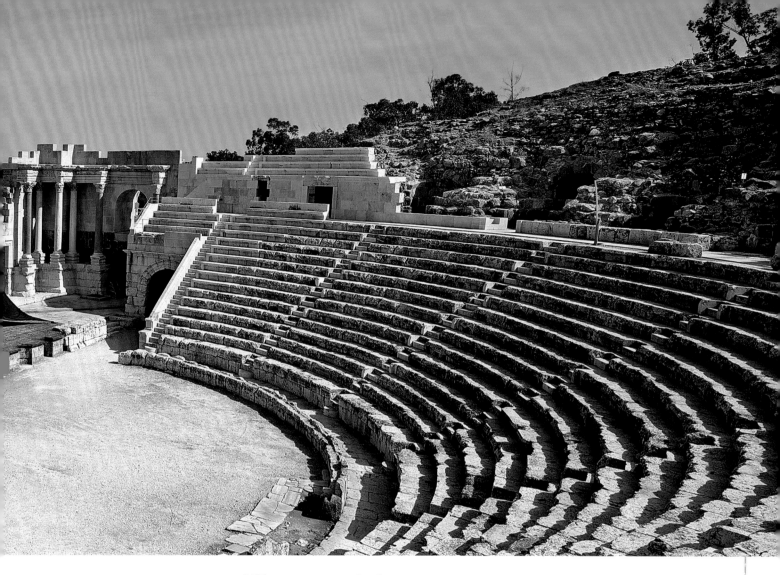

Of course everybody agrees that Jesus of Nazareth was a great teacher, and many are prepared to go at least as far as Nicodemus and call him "a teacher come from God" (John 3:2, NKJV). Further, it is clear that one of the most striking characteristics of Jesus' teaching was the authority with which he gave it. . . . It is this that impressed people so much. As they listened to him, we read, "they were astonished at His teaching, for His word was with authority" (Luke 4:32).

There is only one logical deduction from these things. If the Jesus who thus taught with authority was the Son of God made flesh, we must bow to his authority and accept his teaching. We must allow our opinions to be molded by his opinions, our views to be conditioned by his views. And this includes his uncomfortable and unfashionable teaching . . . like his view of God as a supreme, spiritual, personal, powerful Being, the Creator, Controller, Father and King, and of man as a created being, made in the image of God but now fallen, with a heart so corrupt as to be the source of all the evil things he thinks, says, and does.

—JOHN R. W. STOTT

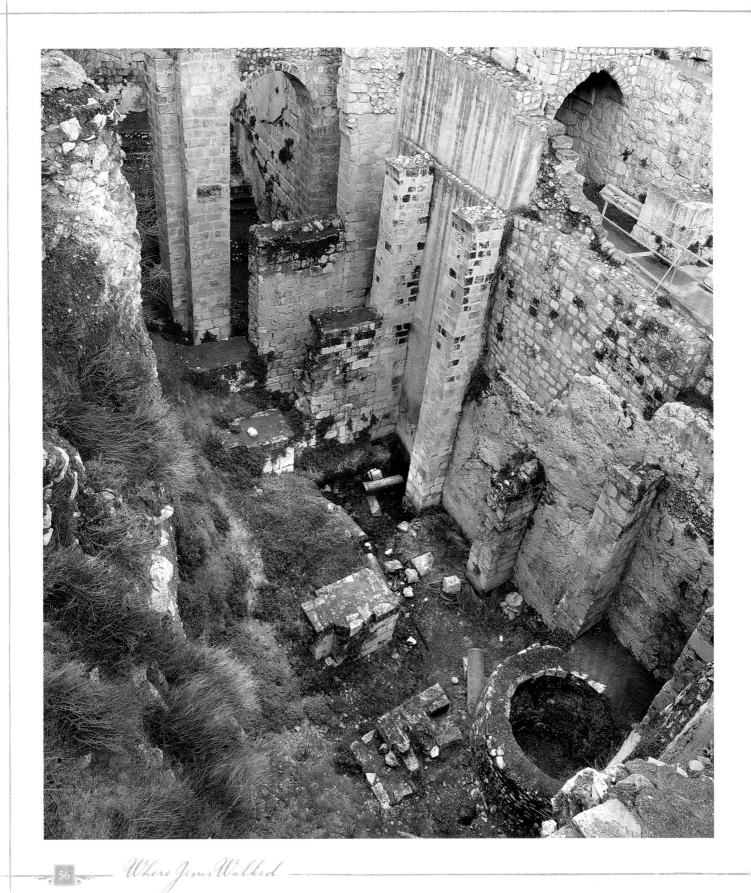

Where Jesus Walked

"SIR," THE INVALID REPLIED,

"I HAVE NO ONE TO *help* ME INTO THE POOL WHEN

THE WATER IS STIRRED. WHILE I AM TRYING TO GET IN,

SOMEONE ELSE GOES DOWN *ahead* OF ME."

THEN JESUS SAID TO HIM,

"GET UP! PICK UP YOUR MAT AND *walk*."

(JOHN 5:7-8)

The invalid at the Pool of Bethesda does what almost all of us are wont to do; for he limits the assistance of God according to his own thought. . . . In this we have a mirror of that forbearance of which every one of us has daily experience, when, on the one hand, we keep our attention fixed on the means which are within our reach, and when, on the other hand, contrary to expectation, he displays his hand from hidden places and thus shows how far his goodness goes beyond the narrow limits of our faith. Besides, this example ought to teach us patience. *Thirty-eight years* was a long period, during which God had delayed to render to this poor man that favor which, from the beginning, he had determined to confer upon him. However long, therefore, we may be held in suspense, though we groan under our distresses, let us never be discouraged by the tediousness of the lengthened period; for, when our afflictions are long continued, though we discover no termination of them, still we ought always to believe that God is a wonderful deliverer who, by his power, easily removes every obstacle out of the way.

—JOHN CALVIN

THE POOL OF BETHESDA, JERUSALEM, ISRAEL

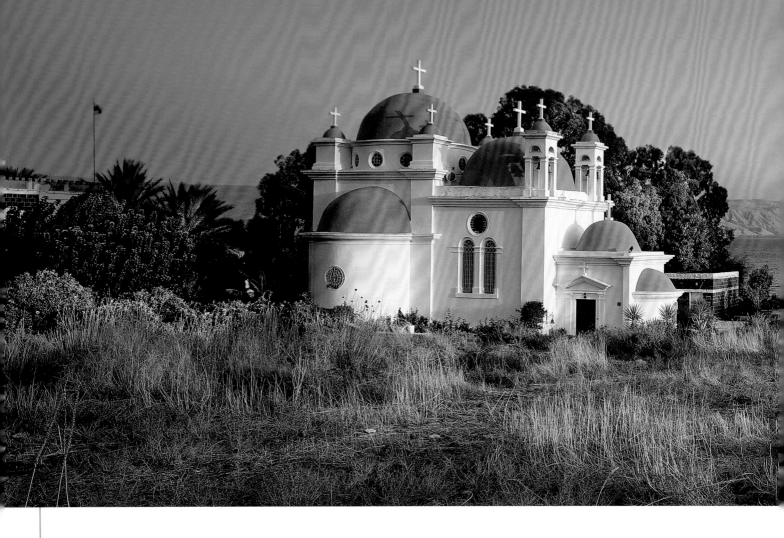

WHEN JESUS HEARD THIS, HE WAS *amazed* AT HIM,

AND TURNING TO THE CROWD FOLLOWING HIM, HE SAID,

"I TELL YOU, I HAVE NOT FOUND SUCH GREAT *faith* EVEN IN ISRAEL."

THEN THE MEN WHO HAD BEEN SENT RETURNED TO THE HOUSE

AND *found* THE SERVANT WELL.

(LUKE 7:9–10)

The Greek [for royal official] is *basilikos* which could even mean that he was a petty king; but it is used for a royal official and he was a man of high standing at the court of Herod. Jesus on the other hand had no greater status than that of the village carpenter of Nazareth. Further, Jesus was in Cana and this man lived in Capernaum, almost twenty miles away. That is why he took so long to get back home.

There could be no more improbable scene in the world than an important court official hastening twenty miles to beg a favour from a village carpenter. First and foremost, this courtier swallowed his pride. He was in need, and neither convention nor custom stopped him from bringing his need to Christ. His action would cause a sensation but he did not care what people said so long as he obtained the help he so much wanted. If we want the help which Christ can give we must be humble enough to swallow our pride and not care what any man may say.

—WILLIAM BARCLAY

"BLESSED ARE THE POOR IN SPIRIT,

FOR THEIRS IS THE *kingdom* OF HEAVEN . . .

BLESSED ARE THOSE WHO ARE PERSECUTED BECAUSE OF *righteousness,*

FOR THEIRS IS THE KINGDOM OF HEAVEN."

(MATTHEW 5:3, 10)

As he begins the Sermon on the Mount, the Lord Jesus Christ tells us eight times in nine verses that blessedness is found in *who we are*. It is a blessedness that comes from being poor in spirit, mourning, being meek, hungering and thirsting after righteousness, being merciful, being pure in heart, being peacemakers, and even from being persecuted!

That last one seems especially strange, doesn't it? *We should be blessed—truly happy—because we're persecuted?* You couldn't get much further from the world's definition of happiness.

Is it any wonder that Jesus' teaching in the Sermon on the Mount so amazed his listeners? . . . Here was the mighty Creator of all speaking to his created ones, telling them that the wellspring of what they craved was found in a sense of his approval.

Yes, friends and loved ones may belittle and ridicule our words and our choices, but what does it matter as long as God continually whispers, *"I know who you are, my child and it brings me pleasure."* Man, after all, was made for God's glory, God's pleasure. How then can man be complete or satisfied until he achieves that for which he was created?

—KAY ARTHUR

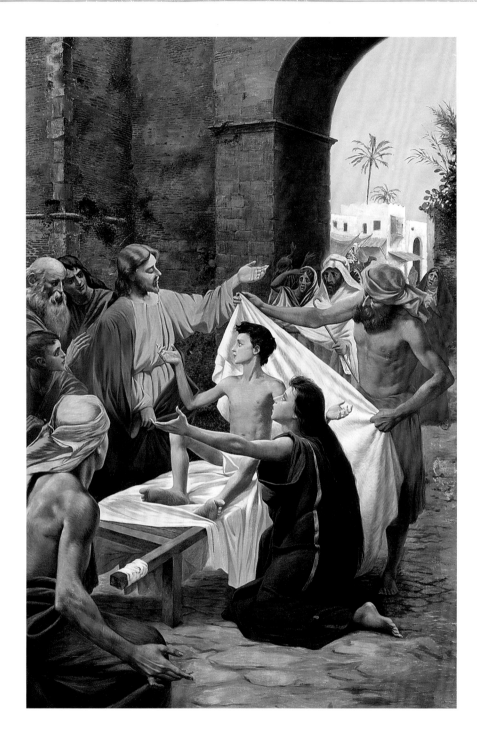

He said,
"Young man,
I say to you, get up!"
The *dead* man sat up
and began to talk,
and Jesus gave
him *back* to
his mother.

(Luke 7:14–15)

Painting of the miracle
of the widow's son,
Nain Church, Israel

*This is where Jesus performed the miracle of restoring
the widow's dead son to life.*

The one thing that stands out so visibly to me in this encounter Jesus had with the widow is that he "saw her" (Luke 7:13). This woman never called for help, did not exercise faith and sought no miracle. Yet Jesus saw her sadness, her grief, and her hurt. He did not look beyond her, like we have a tendency to do. He really saw her.

Jesus not only saw the widow of Nain, "his heart went out to her" (Luke 7:13). He didn't just acknowledge that she was in pain, he suffered with her. A woman with sorrows met the man of sorrows. . . .

God sees you and he feels for you. When you hurt, he hurts. When you are in pain, he is in pain. His love for us moves him to great compassion.

That day in Nain, Jesus crossed the path of a funeral procession. In so doing, he raised a mother's only son to life. But the miracle wasn't for the boy; it was for the mother. Jesus raised a dead man to life, not to bring attention to himself, but to show compassion toward this woman.

—RICK EZELL

EXTERIOR OF NAIN CHURCH, ISRAEL

This church was erected on the traditional site where Jesus healed the widow's son.

THE TWELVE WERE WITH [JESUS],

AND ALSO SOME *women* WHO HAD BEEN CURED OF EVIL

SPIRITS AND DISEASES. . . . THESE WOMEN WERE HELPING

TO SUPPORT THEM OUT OF THEIR *own* MEANS.

(LUKE 8:1–3)

THE AREA OF MAGDALA AND THE
SEA OF GALILEE, TAKEN FROM
MT. ARBEL, ISRAEL

*Magdala, the birthplace of Mary Magdalene,
is the area where Jesus met her and delivered
her from seven evil spirits.*

Mary of Magdala was the *victim of a fearful evil.* She was possessed by not one devil only, but seven. These dreadful inmates caused much pain and pollution to the poor frame in which they had found a lodging. Hers was a hopeless, horrible case. She could not help herself, neither could any human succour avail. But Jesus passed that way, and unsought, and probably even resisted by the poor demoniac, he uttered the word of power, and Mary of Magdala became *a trophy of the healing power of Jesus.* All the seven demons left her, left her never to return, forcibly ejected by the Lord of all. What a blessed deliverance! What a happy change! From delirium to delight, from despair to peace, from hell to heaven! . . . Grace found her a maniac and made her a minister, cast out devils and gave her to behold angels, delivered her from Satan, and united her for ever to the Lord Jesus. May I also be such a miracle of grace!

—C. H. SPURGEON

THEN JESUS BEGAN TO *denounce* THE CITIES IN WHICH
MOST OF HIS *miracles* HAD BEEN PERFORMED,
BECAUSE THEY DID NOT *repent*. "WOE TO YOU, KORAZIN!
WOE TO *you*, BETHSAIDA!"

(MATTHEW 11:20–21)

THE SYNAGOGUE AT KORAZIN, ISRAEL

The Jews of this once-thriving town refused to allow Jesus to preach there. Jesus warned them about their disbelief as many mighty works of the Lord had been performed in their vicinity.

Men will be judged on the basis of the light they had, not on the basis of a light they never saw. The person in the remote jungle who never heard of Jesus is judged differently than the person who is only a broadcast or open Bible away from the gospel.

Jesus explains as much with his harsh criticism of the cities Chorazin and Bethsaida. . . .

Not everyone will be judged by the same standard. The greater our privilege, the greater our responsibilities. Chorazin and Bethsaida saw much, so much was expected of them. The gospel was clearly presented to them, yet they clearly rejected it. . . .

On the other hand, Tyre and Sidon saw less, so less was expected. They, to use the words of Christ, will "get off easier" than others. The principle? God's judgment is based upon humanity's response to the message received. He will never hold us accountable for what he doesn't tell us.

—MAX LUCADO

THEN HE GOT UP AND *rebuked* THE

WINDS AND THE WAVES,

AND IT WAS *completely* CALM.

(MATTHEW 8:26)

To be fair to the disciples, we must remember that up to this point almost everything their Leader had done had been done for others in distress, not for them personally. This was the first time they themselves were in a real jam, and his presence and power had extricated them from sure disaster. For the first time it was they themselves who had to be delivered. For the first time it was they who were not the onlookers but the leading characters in the life-and-death drama enacted before their own eyes. For the first time— if they were to be saved in this hopeless situation—they had to exercise viable faith of their own in Christ. For the first time they had to pocket their pride as a group, come implicitly to the Master, expecting help and finding him faithful to provide it.

He was there in the storm with them. They knew it. Happily, they were humble enough, sensible enough, and sincere enough to seek salvation from the One who could deliver them. And he did. God, in Christ, by his Spirit, is in all the storms of his followers' lives. It is when we give up battling them in our own ability and turn to him that we find relief and rest.

—W. Phillip Keller

SUNRISE OVER THE SEA OF
GALILEE FROM TIBERIAS, ISRAEL

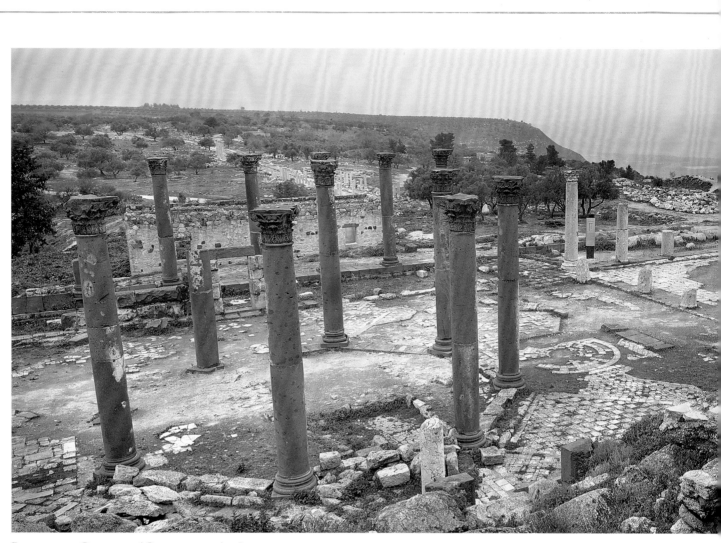

RUINS OF GADARA (GADARENES), JORDAN

This town was known as Gadara, one of the ancient Greco-Roman cities of the Decapolis. This is the most likely area where Jesus sent the demons into the herd of pigs.

FOR JESUS HAD SAID TO HIM, "COME OUT OF THIS MAN, YOU *evil* SPIRIT!"

THEN JESUS ASKED HIM, "WHAT IS YOUR NAME?"

"MY *name* IS LEGION," HE REPLIED, "FOR WE *are* MANY."

(MARK 5:8–9)

The demoniac was a damned man—forgotten and alone. Jesus battled a storm on the sea and rowed seven-and-a-half miles to the region of the damned.

"The other side" was outside of the disciples' comfort zone. But Jesus engaged this madman on his turf, in an area where the people did not look, dress, act, talk, or think like Jews. Gerasenes was a cesspool for human depravity. It was a place of moral and ethical decay. It was a place where sin was rampant and death was a stench on people's clothes. But Jesus still went there to meet the demoniac.

The next time I feel beyond Jesus' reach, or I see people around me as beyond his reach, I will remember the lengths he went to in order to save a madman from destruction. If he was willing to do it then, he is willing to do it now. No matter how far we have fallen, or how desperate we are, Jesus is ready and willing to meet us.

—RICK EZELL

SUNFLOWER, JORDAN VALLEY, ISRAEL

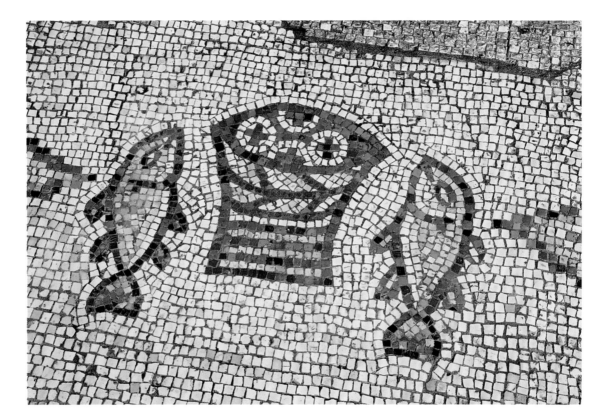

Byzantine mosaic of the loaves and fishes,
the Church of the Multiplication, Tabgha, Israel

Power and Presence

Jesus was seldom far from the Sea of Galilee, a large freshwater lake from which flows the Jordan River. Several of his disciples were veterans of the lake, having fished those waters all their lives. The multiplication of loaves probably occurred on a bluff overlooking the Sea. Jesus spoke from a boat bobbing gently on its surface. And one night he stilled a sudden squall that had produced dangerous turbulent waters. Jesus was on speaking terms with the Sea of Galilee.

Here we walk with Jesus through the waves. Inconceivable? Unbelievable? That's what eleven of the twelve thought as they sat terrified in the boat. But Peter, impulsive as always, leaped over the gunnels and into the lake, and, for a time, also walked on the water. Do we dare to join him or remain safely afraid in the boat?

Gradually the disciples learned that Jesus' presence brought a new world of possibilities as he continually amazed them. Walking with Jesus will have the same effect on us. Sooner or later, we will ask the question, "Who is this man that even the winds and waves obey him?"

DURING THE FOURTH *watch* OF THE NIGHT

JESUS WENT OUT TO THEM,

walking ON THE LAKE.

(MATTHEW 14 : 25)

When Jesus came to the disciples on the water intending "to pass them by" (Mark 6:48, NRSV), he was not just doing a neat magic trick. He was revealing his divine presence and power. . . .

It is interesting that the disciples entered the boat in the first place at Jesus' command. They would have to learn—as do we—that obedience is no guarantee of being spared adversity. But now that the storm had their full attention, Jesus decided it was time the disciples got to know a little bit more about the guy who was piloting this thing. *It's like this, dudes,* he reassured them. *You can trust me. You know my character and my competence. You can safely place your destiny in my hand. Take courage. It's me.*

They didn't fully grasp it yet, but God was visiting them in the water-walking flesh.

Matthew wants his readers to know that Jesus often comes when least expected—3:00 A.M., in the middle of a storm. Those divinely appointed defining moments will come, to you and me. He still asks his followers to do extraordinary things. And if you're not looking for him, you just might miss him.

—JOHN ORTBERG

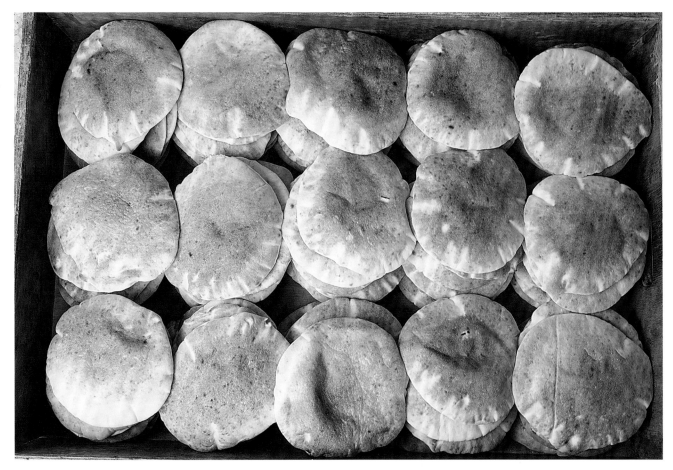

BREAD

THEN JESUS DECLARED,

"I AM THE BREAD OF LIFE. HE WHO *comes* TO ME

WILL *never* GO HUNGRY, AND HE WHO

BELIEVES IN ME WILL *never* BE THIRSTY."

(JOHN 6:35)

Human beings are the only members of God's creatures in this world who do not give their life as material food to another creature. Humans are at the top of the food chain. But not so spiritually. God sent God's only Son, the Word, united with the man Jesus, to be our spiritual food. By his life-giving death, Jesus poured out the life of his body, his blood, so that his blood and body does for us what we cannot do for ourselves—Jesus does relationship for us with God. . . . By ingesting bread and wine, we take into ourselves the life-giving sacrifice of Jesus through whom death is conquered. Bread and wine, eaten and drunk in faith, is the reality of receiving God's life within, through which we are spiritually and physically nourished and sustained. Bread and wine is creation becoming incarnation so that we may become re-creation.

—ROBERT E. WEBBER

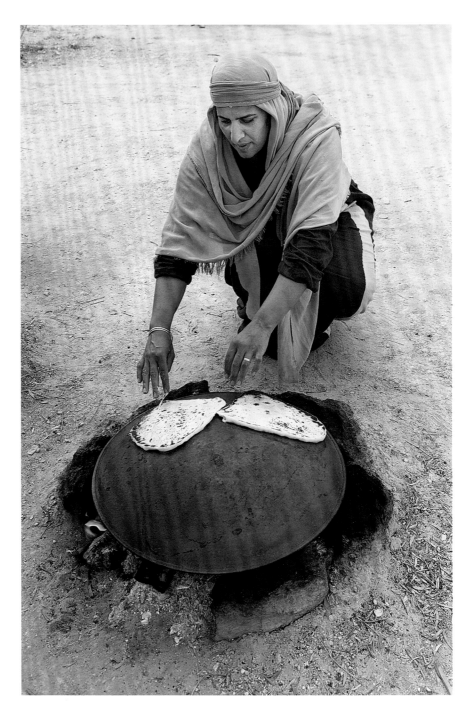

LADY COOKING BREAD, NAZARETH VILLAGE, NAZARETH, ISRAEL

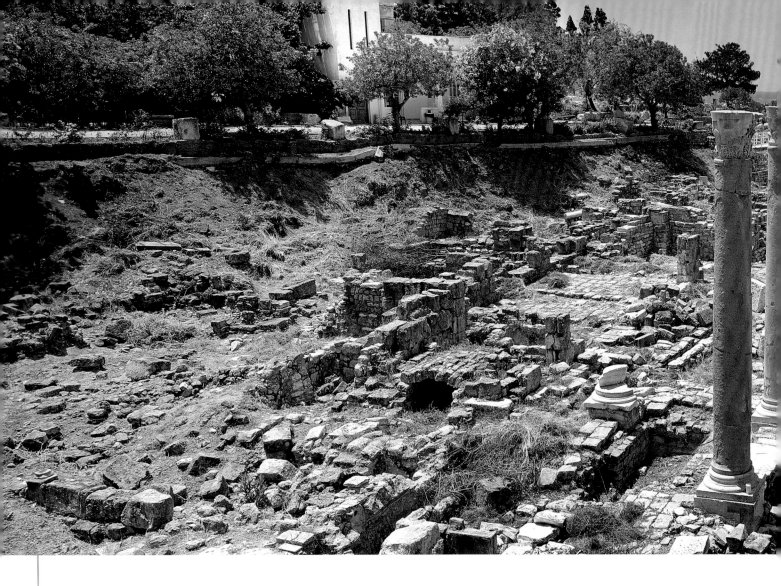

THEN JESUS *answered,* "WOMAN, YOU HAVE GREAT FAITH!
YOUR REQUEST IS GRANTED." AND HER DAUGHTER WAS
healed FROM THAT VERY HOUR.

(MATTHEW 15:28)

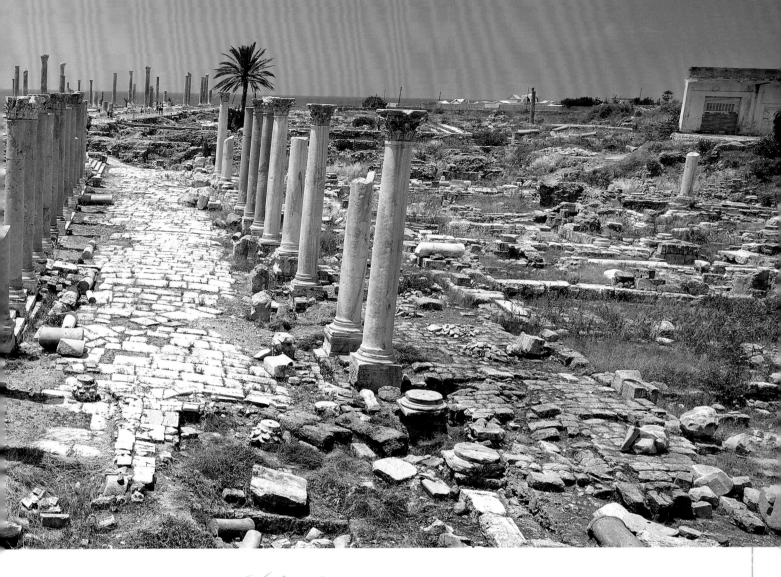

At first, Jesus appears to pay no attention to her agony, and ignores her cry for relief. He gives her neither eye, nor ear, nor word. Silence, deep and chilling, greets her impassioned cry. But she is not turned aside, nor disheartened. She holds on. . . .

This last cry won her case; her daughter was healed in the self-same hour. Hopeful, urgent, and unwearied, she stays near the Master, insisting and praying until the answer is given. What a study in importunity, in earnestness, in persistence, promoted and propelled under conditions which would have disheartened any but a heroic, a constant soul. . . .

An answer to prayer is conditional upon the amount of faith that goes to the petition. To test this, he delays the answer. The superficial pray-er subsides into silence, when the answer is delayed. But the man of prayer hangs on, and on. The Lord recognizes and honors his faith, and gives him a rich and abundant answer to his faith-evidencing, importunate prayer.

—E. M. BOUNDS

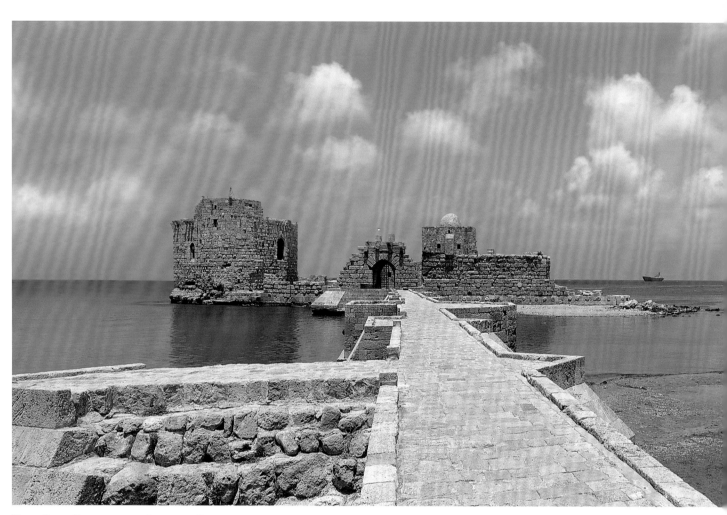

THE SEA FORTRESS, SIDON, LEBANON

This Crusader fortress is built at the opening to Sidon Harbor. Jesus would have spent some time in this area.

GREAT *crowds* CAME TO HIM,

BRINGING THE LAME, THE BLIND, THE CRIPPLED, . . .

AND HE *healed* THEM.

(MATTHEW 15:30)

When Christ came into the world, he was on a mission to accomplish this global redemption. He signaled his purposes by healing many people during his lifetime. There were occasions when the crowds gathered and he "healed all who were sick" (Matthew 8:16; 15:30; Luke 6:19, ESV). This was a preview of what is coming at the end of history when "he will wipe away every tear from their eyes, and death shall be no more, neither shall there be mourning nor crying nor pain anymore" (Revelation 21:4, ESV).

The way Christ defeated death and disease was by taking them on himself and carrying them with him to the grave. God's judgment on the sin that brought disease was endured by Jesus when he suffered and died. The prophet Isaiah explained the death of Christ with these words: "He was wounded for our transgressions; he was crushed for our iniquities; upon him was the chastisement that brought us peace, and *with his stripes we are healed*" (Isaiah 53:5, ESV). The horrible blows to the back of Jesus bought a world without disease.

—JOHN PIPER

SUNSET AT SIDON, LEBANON

A fisherman leaves the safety of Sidon harbor to go fishing overnight in the Mediterranean Sea.

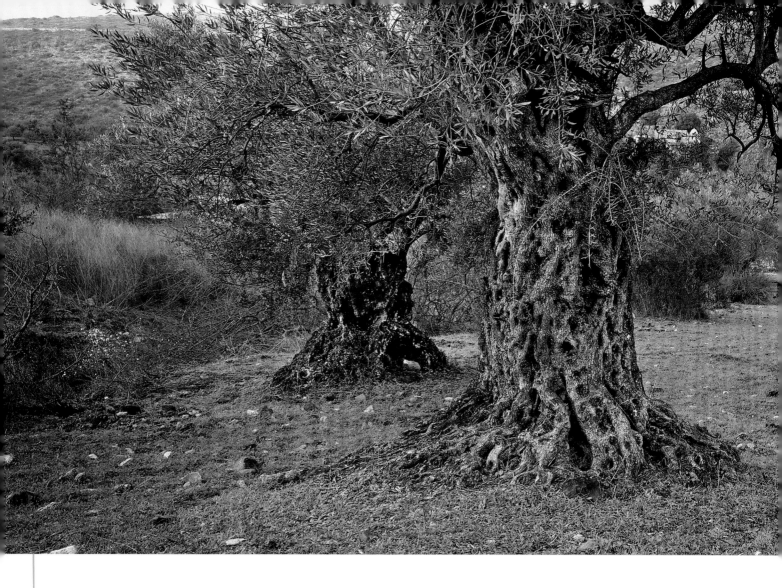

"BUT WHAT ABOUT YOU?" HE ASKED.

"WHO DO *you* SAY I AM?"

SIMON PETER ANSWERED,

"YOU ARE THE CHRIST, THE SON OF THE *living* GOD."

(MATTHEW 16:15–16)

Within this passage there are two great truths.

(1) Essentially Peter's discovery was that human categories, even the highest, are inadequate to describe Jesus Christ. When the people described Jesus as Elijah or Jeremiah or one of the prophets they thought they were setting Jesus in the highest category they could find. It was the belief of the Jews that for four hundred years the voice of prophecy had been silent; and they were saying that in Jesus men heard again the direct and authentic voice of God. These were great tributes; but they were not great enough; for there are no human categories which are adequate to describe Jesus Christ. . . .

(2) This passage teaches that our discovery of Jesus Christ must be a *personal discovery*. . . .

Our knowledge of Jesus must never be at second hand. A man might . . . be able to give a competent summary of the teaching about Jesus of every great thinker and theologian and still not be a Christian. Christianity never consists in *knowing about* Jesus; it always consists in *knowing* Jesus. Jesus Christ demands a personal verdict. He did not ask only Peter, he asks every man: "*You*—what do *you* think of me?"

—WILLIAM BARCLAY

OLIVE GROVE, BANIAS, CAESAREA
PHILIPPI, ISRAEL

*Jesus came to this olive grove with his disciples.
Here Peter proclaimed Jesus' true identity.*

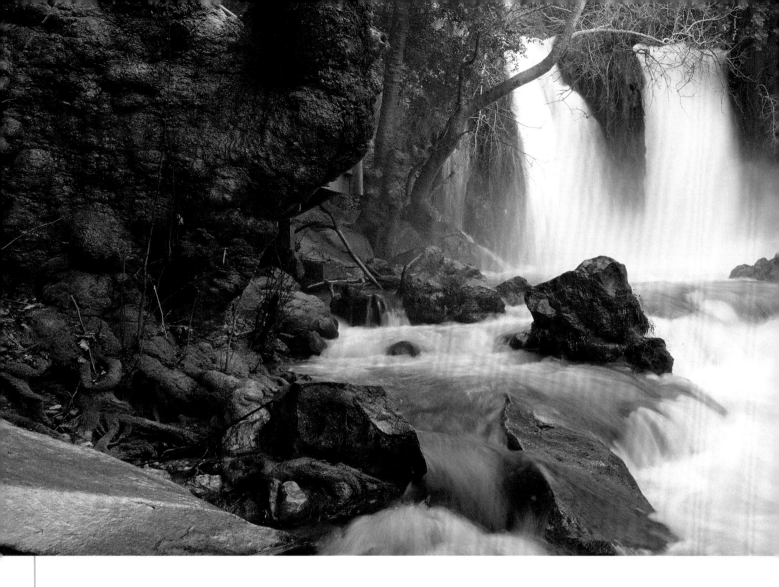

JESUS TURNED AND SAID TO PETER,

"GET *behind* ME, SATAN!

YOU ARE A STUMBLING BLOCK TO ME."

(MATTHEW 16:23)

Later, Jesus quizzed the disciples on his true identity. Peter blurted out, "You are the Christ, the Son of the living God" (Matthew 16:16, NKJV). Jesus blessed him for his answer. But only moments later, as Jesus foretold his coming death, Peter took it upon himself to reprove the Master: "Far be it from You, Lord; this shall not happen to You!" (v. 22). Instead of a blessing from the Lord, Peter received a scathing rebuke: "Get behind Me, Satan! You are an offense to Me" (v. 23).

How would you feel if you were called on the carpet by your church's leadership and accused of being an instrument of the devil—and the rebuke was justified? Would you be tempted to crawl into a hole and never come out? Start shopping for a new church? Yet was it more important for Peter that he misspoke or that he learned the lesson of obedience?

—DAVID JEREMIAH

THERE HE WAS *transfigured* BEFORE THEM.

HIS FACE SHONE LIKE THE SUN,

AND HIS CLOTHES BECAME AS *white* AS THE LIGHT.

(MATTHEW 17:2)

MT. HERMON IN WINTER, ISRAEL

Mount Hermon is one of two mountains thought to be the location of Jesus' transfiguration.

These verses contain one of the most remarkable events in our Lord's earthly ministry, the event commonly called the transfiguration. The order in which it is recorded is beautiful and instructive. The latter part of the last chapter showed us the cross; here we are graciously allowed to see something of the coming reward. The hearts which have just been saddened by a plain statement of Christ's sufferings are at once gladdened by a vision of Christ's glory. . . .

It is good for us to have the coming glory of Christ and his people deeply impressed on our minds. We are sadly apt to forget it. . . . What Christ's people will be has not yet been made known (1 John 3:2): their crosses, their tribulations, their weaknesses, their conflicts, are all plain enough, but there are few signs of their future reward. Let us beware of giving way to doubts in this matter: let us silence such doubts by reading over the story of the transfiguration. There is laid up for Jesus, and all that believe in him, such glory as the human heart never conceived.

—J. C. RYLE

VIEW OF MT. TABOR

AS THEY WERE COMING DOWN THE *mountain,*

JESUS INSTRUCTED THEM,

"DON'T TELL ANYONE WHAT YOU HAVE *seen."*

(MATTHEW 17:9)

We have all experienced times of exaltation on the mountain, when we have seen things from God's perspective and have wanted to stay there. But God will never allow us to stay there. The true test of our spiritual life is in exhibiting the power to descend from the mountain. If we only have the power to go up, something is wrong. It is a wonderful thing to be on the mountain with God, but a person only gets there so that he may later go down and lift up the demon-possessed people in the valley (see Mark 9:14–18). We are not made for the mountains, for sunrises, or for the other beautiful attractions in life—those are simply intended to be moments of inspiration. We are made for the valley and the ordinary things of life, and that is where we have to prove our stamina and strength.

—OSWALD CHAMBERS

BASILICA, MT. TABOR

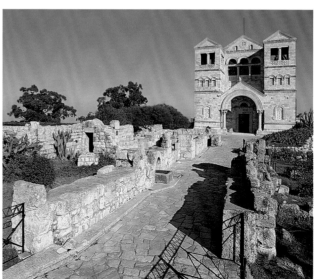

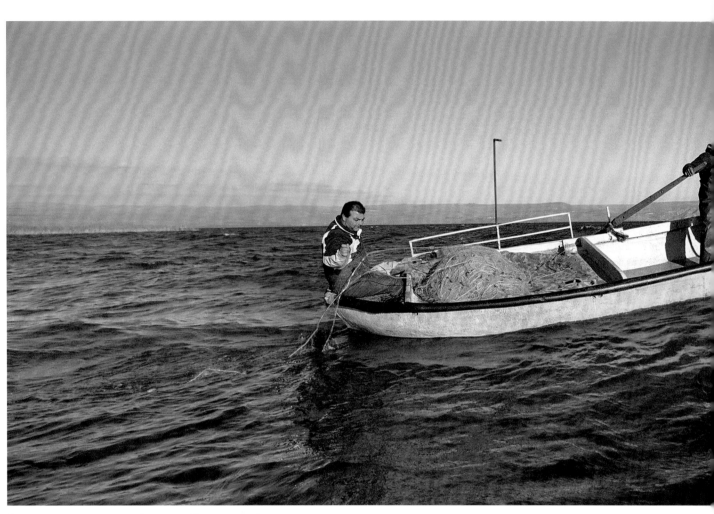

FISHERMEN ON THE SEA OF GALILEE, ISRAEL

"BUT SO THAT WE MAY NOT OFFEND THEM,
GO TO THE *lake* AND THROW OUT YOUR LINE.
TAKE THE FIRST FISH YOU CATCH; OPEN ITS MOUTH AND YOU WILL
FIND A FOUR-DRACHMA COIN. TAKE IT AND *give* IT TO
THEM FOR MY TAX *and* YOURS."

(MATTHEW 17:27)

Where Jesus Walked

If you made a list of all the big creation miracles Jesus did before he came to earth, what would be on it? My list contains galaxies, black holes, solar systems, the law of gravity, the law of thermodynamics, the atmosphere, the asteroid belt, constellations, and photosynthesis. All of them are God-sized wonders.

When this same Lord lived in Palestine, he performed smaller-scale miracles: withering a fig tree; finding a coin in the fish's mouth; healing Peter's mother-in-law of a fever; restoring a man's shriveled hand. He performed powerful miracles, but at a different speed and on a smaller scale than when he created the cosmos.

C. S. Lewis said the Lord's earthly miracles are a retelling in small letters of the very same story that is written across the whole universe in letters too large for some to see. . . .

But I think the most epic of all miracles will be raising us up and transforming our lowly bodies into glorious bodies like our Lord's. Talk about power that's personal! The law of gravity will be turned upside down, and the resurrection of the dead will be written across the whole universe in letters large enough for everyone to see.

—JONI EARECKSON TADA

A ST. PETER'S FISH

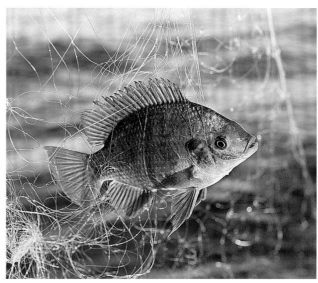

As he was going into a village, ten men who had
leprosy met him. They stood at a *distance* and called
out in a *loud* voice, "Jesus, Master, have pity on us!"

When he saw them, he said,
"Go, show *yourselves* to the priests."
And as they went, they were cleansed.

(Luke 17:12–13)

Leprosy is a wasting disease. It destroys the cells of the body, taking away appendages. . . .

But perhaps the most devastating consequence of all to lepers in biblical times was that their contagiousness meant isolation. They lived in caves, huddled together, wrapped in rags, shunned by all society but each other.

No wonder Jesus had pity on the ten leprous men. No wonder he answered their prayer. . . .

In some way, all of us are like the lepers. We all live at times with our feelings numbed by the harsh realities of life; at times we feel the wasting effects of the enemy's warfare, and at other times we feel bitterly isolated from others.

But the Lord showed us in this story that the way to his healing is open when we pray the way the Samaritan lepers did: with faith to ask the Lord for what we need. Faith to listen for his instructions and follow them. And faith to return to him with gratitude in our hearts.

—CLAIRE CLONINGER

ROMAN RUINS, THE ANCIENT CITY OF SEBASTE, SAMARIA, PALESTINE

Jesus healed ten lepers in this area of Samaria.

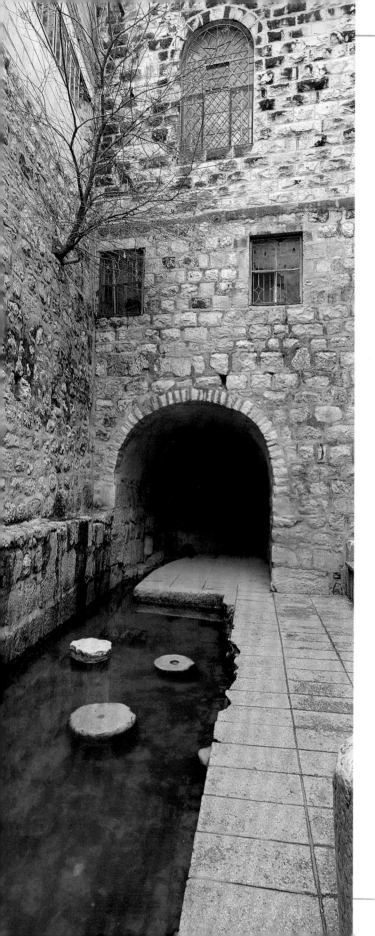

[JESUS] *spit* ON THE GROUND,

MADE SOME MUD WITH

THE SALIVA, AND PUT IT

ON THE *man's* EYES.

"GO," HE TOLD HIM,

"WASH IN THE POOL OF SILOAM". . . .

SO THE MAN *went* AND

WASHED, AND CAME

HOME SEEING.

(JOHN 9:6–7)

THE POOL OF SILOAM, JERUSALEM, ISRAEL

At the Pool of Siloam, Jesus healed a man born blind.

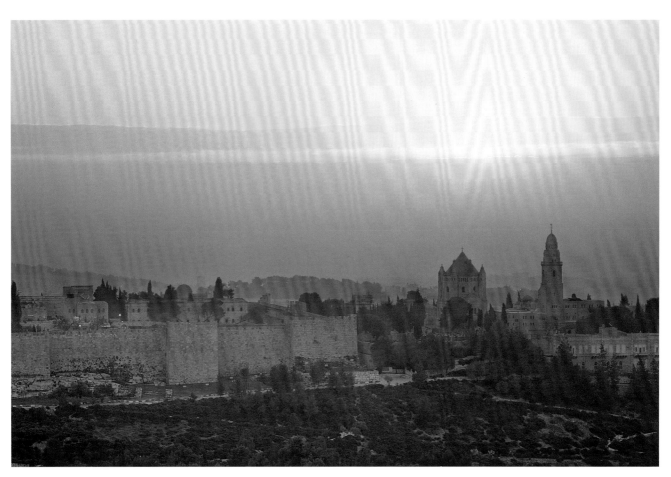

The disciples who first followed Christ were dreadfully out of step with his cause when they pointed out a blind beggar and asked Christ who had sinned—the man's parents, or he in his mother's womb—that he should be born blind (John 9:1–7). No doubt they had seen this beggar many times before and had reacted with the same kind of theological curiosity. What they saw in Christ's response was hardly standoffish. It clearly demonstrated the distance between Christ and his followers in regard to responding to people's needs. His was a response of compassion, not curiosity and judgment. He marshaled his resources to grant sight to the beggar and claimed that the blindness was actually intended to provide a moment when God could be magnified through Christ's compassionate touch.

Aren't we just like those detached disciples? When we hear of trouble in someone's life we are far more interested in the details and an analysis of what, why, when, and where than we are in finding out what we can do to reach out and help.

—JOSEPH STOWELL

Mosaic of Lazarus coming out of the tomb,
the Church of St. Lazarus, Bethany, Palestine

Days of Crisis

Followers and enemies walked with Jesus almost every day. As his influence grew, so did the desperation of those anxious to silence him. They used various strategies, testing him with questions, and confronting him with problems. At other times, as with the woman caught in adultery, they tried to force Jesus into compromise or failure. All of these attempts fell short.

For weeks, Jesus moved steadily toward Jerusalem. He had traveled there before, but this journey had the look and feel of a final visit. He was moving in that direction spiritually as well as geographically. When Jesus told his disciples what would happen, they were conflicted. They resisted the idea of Jesus' death. How could he be the Messiah and yet die? How could he be king and not live to reign? How could someone so powerful be defeated and killed?

Jesus gave them clues and clear answers, but they remained unconvinced, unprepared, and troubled. Although the ominous future made them fear for their own lives, they continued to walk with Jesus. They didn't abandon him—yet. Thomas seems to have expressed their inner turmoil with a unique flavor of resigned faithfulness with his statement, "Let us also go, that we may die with him" (John 11:16).

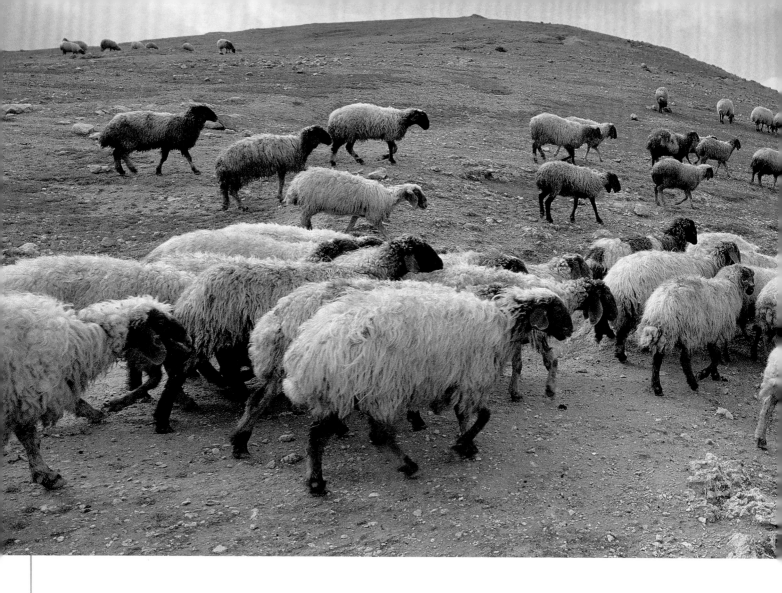

"I AM THE *good* SHEPHERD; I KNOW MY SHEEP

AND MY SHEEP KNOW ME—JUST AS THE FATHER KNOWS ME

AND I *know* THE FATHER—AND I LAY DOWN

MY LIFE FOR THE SHEEP.

(JOHN 10:14-15)

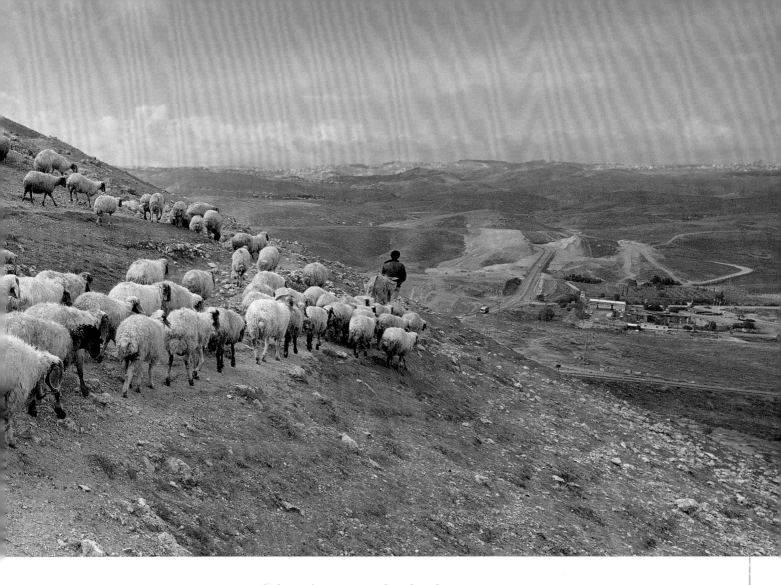

God is the comic shepherd who gets more of a kick out of that one lost sheep once he finds it again than out of the ninety and nine who had the good sense not to get lost in the first place. God is the eccentric host who, when the country-club crowd all turn out to have other things more important to do than come live it up with him, goes out into the skid rows and soup kitchens and charity wards and brings home a freak show. . . . They are seated at the damask-laid table in the great hall. The candles are all lit and the champagne glasses filled. At a sign from the host, the musicians in their gallery strike up "*Amazing Grace.*" If you have to explain it, don't bother. . . .

Is it possible, I wonder, to say that it is only when you hear the gospel as a wild and marvelous joke that you really hear it at all? Heard as anything else, the gospel is the church's thing, the preacher's thing, the lecturer's thing. Heard as a joke—high and unbidden and ringing with laughter—it can only be God's thing.

—FREDERICK BUECHNER

SHEEP WITH SHEPHERD ON THE ROAD TO JERICHO, ISRAEL

"IT WOULD BE *better* FOR HIM TO BE THROWN INTO THE SEA WITH A MILLSTONE TIED AROUND HIS NECK THAN FOR HIM TO CAUSE ONE OF THESE LITTLE ONES TO *sin*."

(LUKE 17:2)

Leading another person astray is very serious. Jesus explained that the consequences were so severe that it would be *better* to have a *millstone* tied around one's neck and be *thrown into the sea* than for a person to face God after causing others to stumble. A "millstone" was a heavy, flat stone used to grind grain. . . . To have a millstone tied around the neck and be dumped into the sea pictured a horrifying death by drowning. Even such a death would be minor, however, compared to what this person would face in eternity.

Jesus used the term "little ones" to refer not just to children but to his followers. This pictures children who are trusting by nature. As children trust adults, and as adults prove to be trustworthy, the children's capacity to trust in God grows. God holds parents and other adults who influence young children accountable for how they affect these little ones' ability to trust God. . . .

But Jesus' warning envisions an additional group. The "little ones" can be new disciples. Indifference to the training and treatment of new Christians can leave them theologically vulnerable. Make the follow-through care of recent converts and new members a high priority in your church.

—LIFE APPLICATION BIBLE COMMENTARY—LUKE

MILLSTONE *(left)*

MILLSTONE, NAZARETH VILLAGE *(inset)*

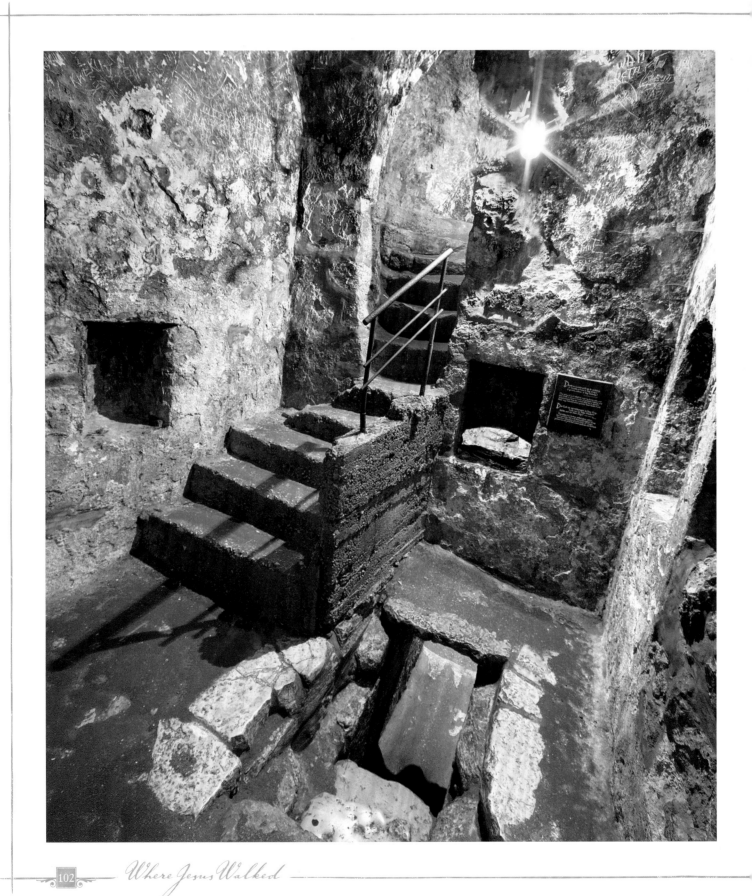

JESUS CALLED IN A LOUD VOICE,

"LAZARUS, COME OUT!" THE *dead* MAN CAME OUT, HIS HANDS

AND FEET WRAPPED WITH STRIPS OF LINEN,

AND A CLOTH *around* HIS FACE.

(JOHN 11:43-44)

What Jesus did with Lazarus, he is willing to do with us. Which is good to know, for what Martha said about Lazarus can be said about us, "But, Lord, it has been four days since he died. There will be a bad smell" (John 11:39, NCV). Martha was speaking for us all. The human race is dead, and there is a bad smell. We have been dead and buried a long time. We don't need someone to fix us up; we need someone to raise us up. In the muck and mire of what we call life, there is death, and we have been in it so long we've grown accustomed to the stink. But Christ hasn't.

And Christ can't stand the thought of his kids rotting in the cemetery. So he comes in and calls us out. We are the corpse, and he is the corpse-caller. We are the dead, and he is the dead-raiser. Our task is not to get up but to admit we are dead. The only ones who remain in the grave are the ones who don't think they are there.

The stone has been moved. "Lazarus!" he yells. "Larry! Sue! Horatio! Come out!" He calls.

—MAX LUCADO

TOMB OF LAZARUS IN BETHANY, ISRAEL

This is the tomb in which Lazarus lay when Jesus raised him from the dead.

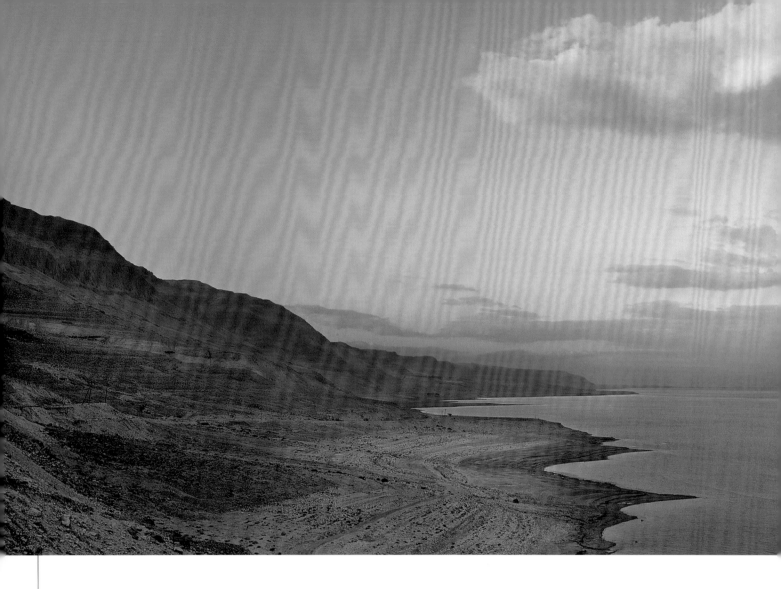

"IF YOU HAVE *faith* . . . YOU CAN SAY TO THIS MOUNTAIN,

'GO, THROW YOURSELF *into* THE SEA,'

AND IT *will* BE DONE."

(MATTHEW 21:21)

Jesus had cursed the fig tree; the fig tree had died; the disciples had expressed surprise. Jesus explained that they could ask anything of God and receive an answer. . . . They should not have been surprised that a fig tree could be withered at Jesus' words. Jesus was using a mountain as a figure of speech to show that God could help in any situation: *This mountain* (referring to the Mount of Olives on which they stood) *could be thrown into the sea* (the Dead Sea, which could be seen from the Mount). Jesus' point was that in their petitions to God they must believe without doubting (that is, without wavering in their confidence in God). The kind of prayer Jesus meant was not the arbitrary wish to move a mountain of dirt and stone; instead, he was referring to prayers that the disciples would need to faithfully pray as they faced mountains of opposition to their gospel message in the years to come. Their prayers for the advancement of God's kingdom would always be answered positively—in God's timing.

—LIFE APPLICATION COMMENTARY—MATTHEW

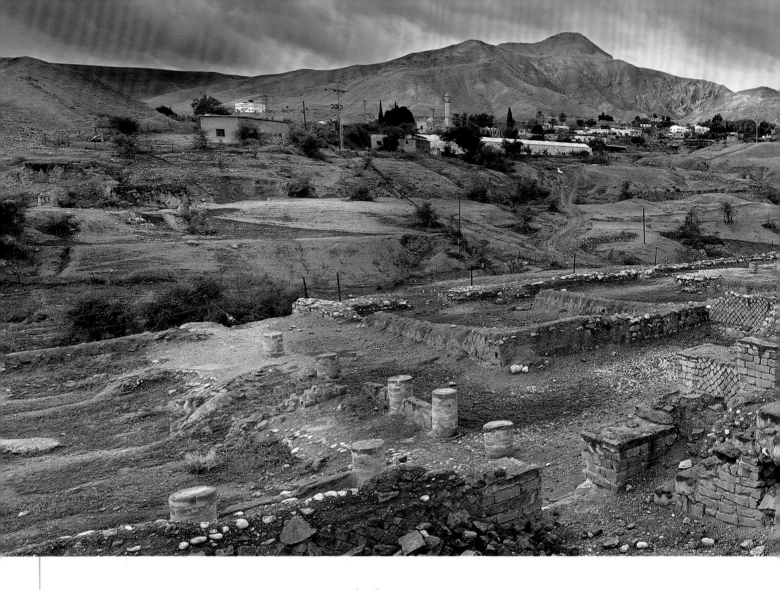

As Jesus *approached* Jericho, a blind man was sitting
by the roadside begging.

"What do you want *me* to do for you?"

"Lord, I want to see," he replied.

Jesus said to him, "Receive your sight; your *faith* has
healed you." Immediately he received his sight and
followed Jesus, praising God. When all the people saw it,
they also praised God.

(Luke 18:35, 41–43)

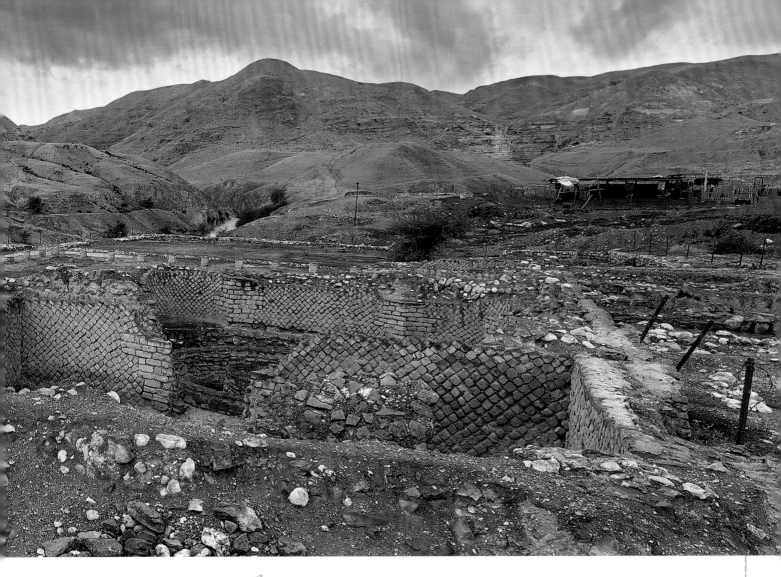

HEROD THE GREAT'S WINTER PALACE, WADI QELT, JERICHO, PALESTINE

Jesus would have seen this palace on his trip from Jerusalem to Jericho.

Jesus' question puzzles some people. If he's really the Messiah, then why should he have to ask the man what he wanted? Wouldn't it be obvious? It doesn't take a medical doctor to identify a blind beggar who for years has been crawling around, seeking handouts. Why did Jesus ask, "What do you want Me to do for you?" (Luke 18:41, NKJV).

First, we should remember that God often asks us questions, not to gain information but to get us to admit our need. . . .

Second, the Bible makes it clear that while "all things are possible with God" (Mark 10:27, NIV), it reminds us that we can't expect to tap into his miracle-working power without explicit prayer. . . .

So Jesus turns to this sightless man and asks, "What do you want me to do for you?"

The man doesn't wait to respond. He knows his need. He believes he is speaking with Israel's long-promised Messiah. And so he says simply, "Lord, that I may receive my sight" (Luke 18:41, NKJV). . . .

May we have the spiritual insight of the man *formerly* known as the blind beggar from Jericho!

—GREG LAURIE

[ZACCHAEUS] WAS A
CHIEF *tax* COLLECTOR AND
WAS WEALTHY. HE WANTED
TO SEE WHO JESUS WAS,
BUT BEING A *short* MAN HE
COULD NOT, BECAUSE OF
THE CROWD. SO HE RAN
AHEAD AND *climbed*
A SYCAMORE-FIG TREE
TO SEE HIM, SINCE *Jesus*
WAS COMING THAT WAY.

(LUKE 19:2-4)

THE ZACCHAEUS TREE, JERICHO, PALESTINE

This tree is said to be over two thousand years old and could have been the very tree that Zacchaeus climbed when Jesus visited Jericho.

Zacchaeus's approach to life involved compensating for his physical shortness by elevating himself in other ways. He was too short to be noticed, but as a rich tax collector he got plenty of attention. He came late to the parade and couldn't see over the crowd, so he climbed a tree. Zacchaeus wanted to see Jesus but suddenly found himself the object of observation.

As you pass through the world today, remember Zacchaeus in two ways. First, do you identify with his frustration at not being noticed? Do you sometimes wonder whether Jesus would have given you a glance if you had been in Zacchaeus's place? Remember that Jesus knew Zacchaeus's heart as well as he knew the man's name. Jesus knows you, too, and would never miss you in a crowd. Second, how many people will go unnoticed by you today? Make a special effort to notice as many as you can—use people's names; speak to people who don't expect it; show an interest in others' lives. Read the rest of Zacchaeus's story for the delightful results of Jesus' interest. You may get some wonderful surprises by noticing others.

God doesn't overlook anybody.

—NEIL WILSON

THE HILLS OUTSIDE JERICHO

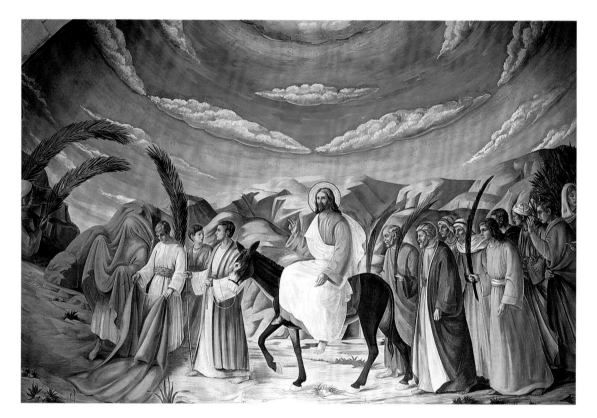

PALM SUNDAY, JESUS' TRIUMPHAL ENTRY INTO JERUSALEM,
THE SANCTUARY OF BETHPAGE, ISRAEL

Triumph and Tension

The air that morning seemed shot through with anticipation. Pilgrims on their way to Jerusalem for the Passover knew they would be in the city by nightfall. For many of them, this would be their first time in David's City. The traditional Psalms of Ascent were on everyone's lips. People were in a mood to praise God!

Then news spread through the crowd that Jesus the prophet, healer, and some said Messiah, was among them. Mounted on a young donkey, Jesus reminded many of the ancient tradition of kings riding on colts when they approached the great city in peace. The sign represented humility more than royalty. And that's why this entrance into Jerusalem was all the more triumphant—because his purpose wasn't triumph. Jesus had a victory of a different kind in mind—one that would require the ultimate sacrifice.

As we follow Jesus through Jerusalem, we soon realize that he walked there in our place, for our benefit. He took the painful steps that led to the cross—on our behalf. Isaiah described this process centuries earlier when he wrote, "But he was pierced for our transgressions, he was crushed for our iniquities; the punishment that brought us peace was upon him, and by his wounds we are healed" (Isaiah 53:5).

Jesus walked for us.

THEY *brought* THE DONKEY AND THE COLT,

PLACED THEIR CLOAKS ON THEM, AND JESUS SAT ON THEM.

A VERY *large* CROWD SPREAD THEIR CLOAKS ON THE ROAD,

WHILE OTHERS CUT BRANCHES FROM THE TREES

AND SPREAD THEM ON THE ROAD. THE CROWDS THAT WENT

AHEAD OF HIM AND THOSE THAT *followed* SHOUTED. . . .

(MATTHEW 21:7–9)

The road of Jesus' triumphal
entry into Jerusalem, Israel

The rabbis had said, "When the Messiah comes, if Israel is ready, he will come riding a white horse. But if Israel is not ready, he will ride a foal." When Jesus of Nazareth appeared outside Jerusalem on the afternoon of that tenth day of the month of Nisan, A.D. 33, he was riding a foal. . . .

There are many misunderstandings concerning the final entry into Jerusalem, but the focus of the misconceptions is Jesus himself. He is the misunderstood Messiah. . . .

The disciples talked about thrones on the way to Jerusalem, even though Jesus had been talking about crosses. . . . The disciples were singing. Jesus was weeping. The disciples thought Israel was ready for the Messiah, but Jesus was riding a colt.

Jesus' first coming was characterized by misunderstanding. But there will be a second. The misunderstood Messiah, who that day was a Lamb, will return as a Lion. *Every* eye will see him then, and not simply a few followers in a crowd. No one will misunderstand. . . . This time there will indeed be thrones. Revelation tells us Jesus will be riding a white horse. Does it mean we will be ready?

—MICHAEL CARD

The Wailing Wall, the Temple Mount, Jerusalem, Israel

Jesus *entered* the temple area

and drove out all who *were*

buying *and* selling there.

(Matthew 21:12)

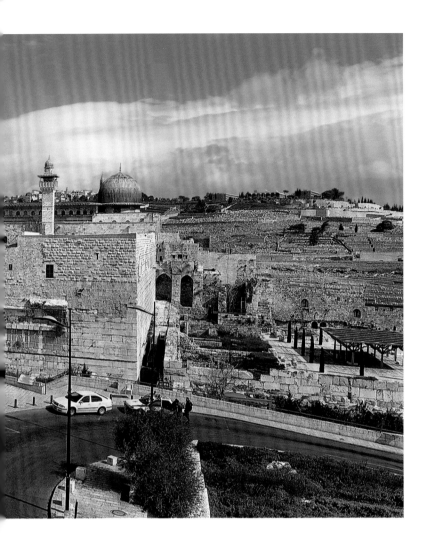

Whenever you and I hear the word meek, our minds tend to think weak. But meek is not weak. Not even close. . . .

Strength under control.

Power under discipline.

Jesus is the prime example of a meek person. Was Jesus weak? Well, go back and watch him as he cleans out the temple. With a whip made out of cords, he drove everyone out of the temple courtyard in extremely short order. No one struggled with him. No one challenged him. I find it hard to believe some wimp could have accomplished this. No one wanted to mess with the man from Nazareth. He was very strong and had great authority . . . but he also characterized himself as a meek person. . . .

Jesus was meek. He had the greatest possible strength under the greatest possible control. While he was on the cross, he could have called ten legions of angels to come to his aid. But he stayed on that cross and held his vast power in check . . . out of love for you and me.

—DAVID JEREMIAH

MAN AT THE WAILING WALL, JERUSALEM, ISRAEL

This wall formed part of the foundation of the old Jewish temple of Jerusalem built by King Solomon. Thus Jews consider it to be holy.

THE CARDO MAXIMUS, JERUSALEM, ISRAEL

This was the main market area at the time of Jesus, so Jesus would have walked on this street.

"AT THAT TIME THE *kingdom* OF HEAVEN WILL BE LIKE TEN
VIRGINS WHO TOOK THEIR LAMPS AND WENT OUT TO MEET THE BRIDEGROOM.

"'NO,' THEY *replied*, 'THERE MAY NOT BE ENOUGH FOR BOTH US AND YOU.

INSTEAD, GO TO THOSE WHO SELL OIL AND BUY SOME FOR *yourselves.'*

"BUT WHILE THEY WERE ON THEIR WAY TO *buy* THE OIL,
THE BRIDEGROOM ARRIVED. THE VIRGINS WHO WERE READY WENT IN
WITH HIM TO THE WEDDING BANQUET. AND THE *door* WAS SHUT."

(MATTHEW 25:1, 9–10)

Who are the foolish virgins? . . . They do not stand in God's presence in the truth of their consciences, holding their good lives before him. Instead they try to seem good in the eyes of men and women, conforming to the judgment of others. . . . It is aptly said that such people do not bring oil with them, for on account of its power to burn and shine brightly oil represents a glowing reputation. . . . But their flames will gutter and go out, because they are not fed with oil from within. . . .

When the moment comes, and the bridegroom is almost here, . . . the good conduct of the foolish virgins will have petered out, for oil in their consciences will be lacking, and they will not find anyone to sell them what they used to obtain from their flatterers. . . . The foolish had tried to beg from the wise: *Give us some oil or our torches are going out* (Matthew 25:8). *How did the wise respond? There may not be enough for both us and you. Better that you go to the sellers, and buy some for yourselves.* (Matthew 25:9) This amounted to a warning: "What use are they to you now, those people from whom you are accustomed to purchase adulation?"

—AUGUSTINE

OIL LAMP FROM THE TIME OF JESUS

This lamp was found in an area that Mary, Joseph, and Jesus visited. Perhaps the family used this very lamp.

THEN *one* OF THE TWELVE . . . WENT TO THE CHIEF PRIESTS
AND ASKED, "WHAT ARE *you* WILLING TO GIVE ME IF
I HAND HIM OVER TO YOU?" SO THEY COUNTED OUT
FOR HIM THIRTY SILVER *coins*.

(MATTHEW 26:14–15)

Jesus really did abandon power when he lived among us. He wasn't simply holding back and pretending to possess our physical limitations—he truly was one of us. We don't like that fact and do our best to suppress it. We want to think of him disguising himself as a sophisticated Rotarian who could step into a phone booth, rip off his robes, and show us who he is—a first-century Clark Kent/Superman.

Judas was one who refused to accept such a limited Messiah. On Palm Sunday, power had been within the Master's grasp. It was the logical time to take over. It was the opportunity to rally the masses to the cause, the hour when he should claim power. And Jesus let it all slip away.

Some think that Judas betrayed Jesus in order to force him to play the power game and establish his rule. Those who hold this theory suggest that Judas felt that if Jesus were left with no alternative, he would be forced away from his reluctance to seize the throne. If that was the plan of Judas, it all backfired. Perhaps it was when he realized that his attempt to manipulate Jesus into using power only resulted in the death of one who had loved him infinitely that Judas hanged himself.

—TONY CAMPOLO

SILVER COINS FROM THE TIME OF JESUS *(left)*

These silver coins are similar to the ones paid to Judas for betraying Jesus.

WIDOW'S MITE COINS FROM THE TIME OF JESUS *(inset)*

These coins are similar to the one Jesus mentioned in the story of the widow's mite.

THE CENACLE, OR COENACULUM, THE ROOM OF THE LAST SUPPER, MT. ZION, JERUSALEM, ISRAEL

This room (a fourteenth-century renovation) is believed to be where Jesus and his disciples celebrated the Last Supper and where he washed his disciples' feet.

[JESUS] REPLIED,

"GO INTO THE CITY TO A *certain* MAN AND TELL HIM,

'THE TEACHER SAYS: MY APPOINTED TIME IS NEAR.

I AM GOING TO *celebrate* THE PASSOVER

WITH MY DISCIPLES AT YOUR HOUSE.'"

(MATTHEW 26:18)

"This cup is the new covenant in my blood" (Luke 22:20), Jesus explained, holding up the wine.

The claim must have puzzled the apostles. They had been taught the story of the Passover wine. It symbolized the lamb's blood that the Israelites, enslaved long ago in Egypt, had painted on the doorposts of their homes. That blood had kept death from their homes and saved their firstborn. It had helped deliver them from the clutches of the Egyptians.

For thousands of generations the Jews had observed the Passover by sacrificing the lambs. Every year the blood would be poured, and every year the deliverance would be celebrated.

The law called for spilling the blood of a lamb. That would be enough.

It would be enough to fulfill the law. It would be enough to satisfy the command. It would be enough to justify God's justice.

But it would not be enough to take away sin.

". . . because it is impossible for the blood of bulls and goats to take away sins" (Hebrews 10:4, NCV).

Sacrifices could offer temporary solutions, but only God could offer the eternal one.

So he did.

—MAX LUCADO

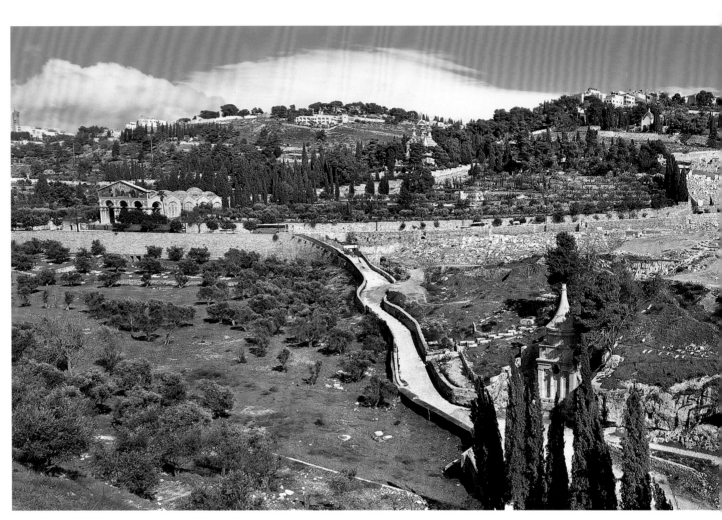

THE KIDRON VALLEY, JERUSALEM, ISRAEL

Jesus would have walked through this valley on his way to the Last Supper and on his way to pray in the Garden of Gethsemane.

"I AM THE VINE; YOU ARE THE BRANCHES.

IF A MAN REMAINS IN *me* AND I IN HIM,

HE WILL BEAR MUCH FRUIT;

apart FROM ME YOU CAN DO NOTHING."

(JOHN 15:5)

One of the most appealing features of the gospel has to be the prospect of change. God replaces old, wrong attitudes and habits. He gives us new abilities and opportunities to make an impact. In short, God wants to work in us and through us.

The Bible, in describing this process of spiritual growth, often uses agricultural imagery. In the words of Christ, we read that as we mature in our faith, we will bear "fruit." But notice what Jesus says: We must "remain" in him. Separate a branch from its life-giving vine, and the branch not only ceases to bear fruit, it also withers and dies.

In verse 2 of John 15, Christ reveals that branches must be pruned to increase their production of fruit. This is an unsettling image and a painful thought, but the idea seems to be twofold: (1) there can be no growth or fruitfulness without pain, and (2) the Lord uses our troubles for his glory and our good. The next time the pain of "pruning" feels unbearable, ask God to help you to focus on the growth and fruitfulness Christ is producing in you.

—LEN WOODS

GRAPES FROM JERICHO, PALESTINE

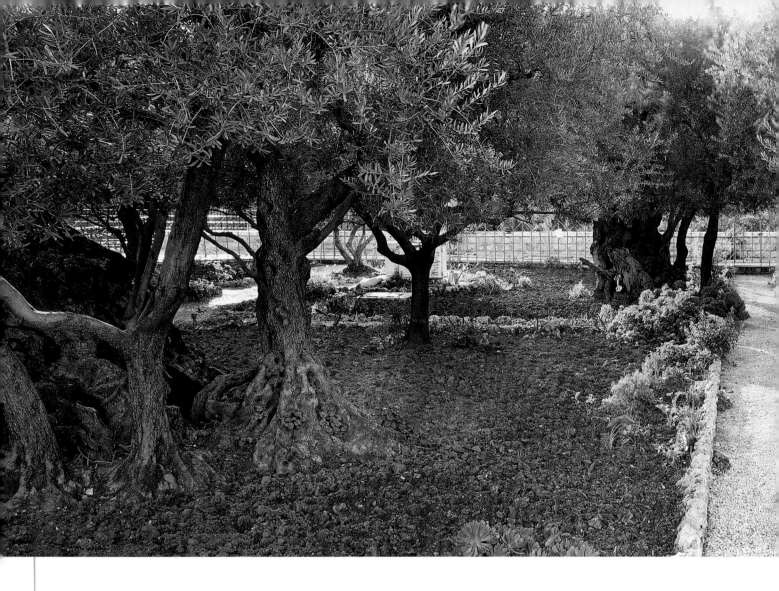

GOING A LITTLE FARTHER,

HE FELL WITH HIS *face* TO THE GROUND AND PRAYED,

"MY FATHER, IF IT IS POSSIBLE, MAY THIS CUP BE TAKEN FROM ME.

YET NOT AS I WILL, BUT AS *you* WILL."

(MATTHEW 26:39)

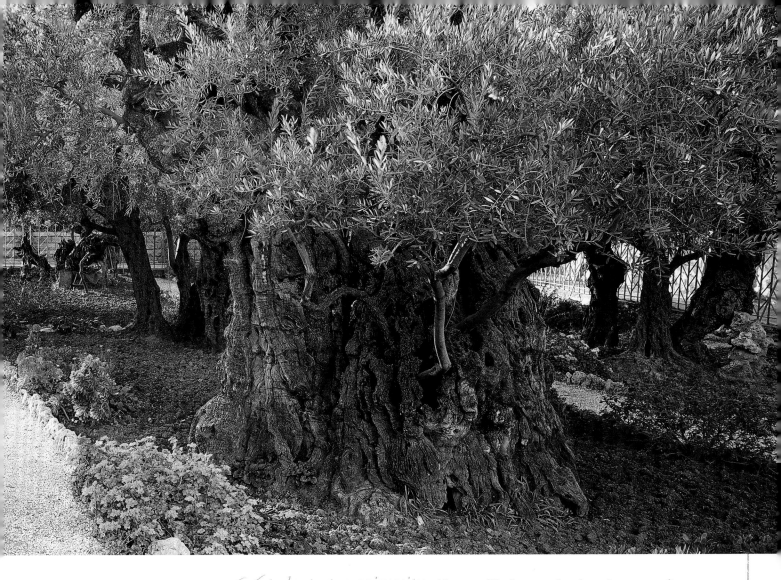

A student at a university said to me, "I often wonder about Jesus struggling at Gethsemane over the impending crucifixion. What was happening there? Jesus asking to be spared the cup? It sounds crazy to me," he said.

I answered, "Ponder with me for a moment. The cup of human sin was to be drunk to the last dregs by the purest one of all. The most painful physical torture was that of being crucified. Yet the Lord Jesus did not fear the physical pain. The only indivisible entity in the world is the very Holy Trinity. The possibility of his Father turning away from him when he was subjected to the accursedness of sin was paramount in his mind. But he knew that if that was the only way to accomplish salvation, he would do it. . . .

"Look at the Cross, now Evil is seen for what it is—all the vileness in the human heart is there in the face of the perfectly pure. Evil is not covered up. See again the marvel of God's love that offers forgiveness of such evil. . . ."

There was silence and then the student said one word: "Awesome." He muttered again, "Just awesome."

—RAVI ZACHARIAS

THE GARDEN OF GETHSEMANE,
JERUSALEM, ISRAEL

NOW THE *betrayer*
HAD ARRANGED A
SIGNAL *with* THEM:
"THE ONE I KISS
IS THE MAN;
arrest HIM."
GOING AT *once*
TO JESUS, JUDAS SAID,
"GREETINGS, RABBI!"
AND *kissed* HIM.

(MATTHEW 26:48–49)

PILLAR OF THE KISS,
THE GARDEN OF GETHSEMANE,
JERUSALEM, ISRAEL

*This pillar marks the traditional place where Judas
betrayed Jesus with a kiss.*

Whispered voices and soft wind in the olive trees gave way to the rumble of mob feet. Torches flared in the darkness, casting shadows on angry and determined faces. Sleep gave way to terror as disciples realized they were the objective of the armed hunt. A confusing confrontation followed. Judas, backed by clubs and swords, approached and kissed Jesus, picking him out of the dim lineup. Others stepped up to take custody. In the chaos, Peter lashed out with a sword, hewing someone's ear in a stunning display of characteristic impulsiveness and poor swordsmanship. Jesus' apparent unwillingness to resist arrest further flustered the disciples and they saw no other recourse but to run. Those who had vowed to stand to the end dashed into the night.

The cowardice of the disciples seems culpable until we begin to think about the ways we stand with Jesus in the darkness of the world. Thinking about their responses under pressure gives us opportunities to consider how often we run for cover at the first sign of danger. And perhaps even more significantly, we can gain a deeper understanding of the way God responds when we prove unfaithful under fire.

—NEIL WILSON

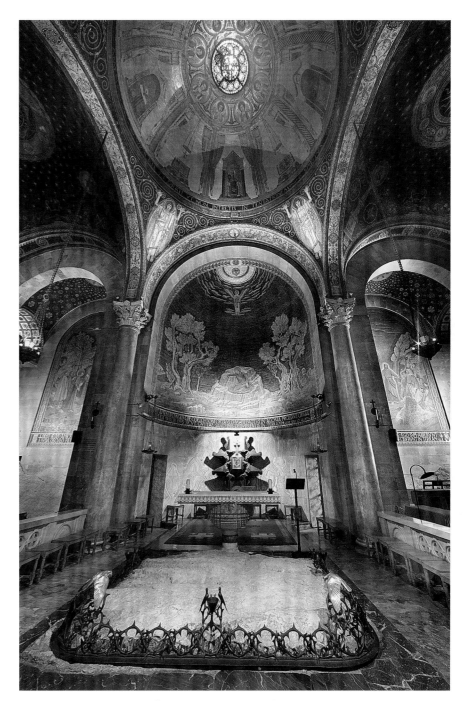

THE BASILICA OF THE AGONY, JERUSALEM, ISRAEL

This church in the Garden of Gethsemane is believed to be where Jesus prayed fervently. The rock in the foreground, called the Rock of the Agony, is thought to be the exact spot where he prayed.

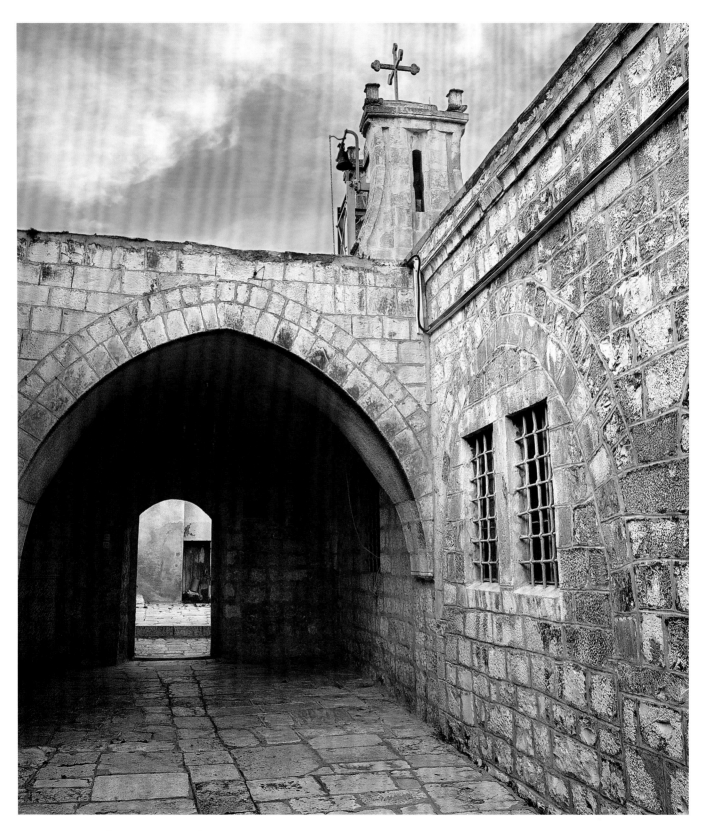

Where Jesus Walked

THEN THE *detachment* OF SOLDIERS WITH ITS

COMMANDER AND THE JEWISH OFFICIALS ARRESTED JESUS.

THEY BOUND HIM AND BROUGHT HIM *first* TO ANNAS.

(JOHN 18:12–13)

Both Annas and Caiaphas had been high priests. Annas was Israel's high priest from A.D. 6 to 15, when he was deposed by Roman rulers. Caiaphas, Annas's son-in-law, was appointed high priest from A.D. 18 to 36/37. . . . Although Annas retained much authority among the Jews, Caiaphas made the final decisions. Very likely, Annas had asked to interrogate Jesus and was given the first rights to do so (see 18:19–23). . . .

In 11:49–52, Caiaphas had advised the Jewish leaders that it was expedient for one man to die on behalf of the people. Caiaphas said this because he feared the Romans. The Jews had limited religious freedom so long as they kept the peace. The Jewish leaders feared that Jesus' miracles and large following would cause Rome to react and clamp down on them. . . .

Both Caiaphas and Annas cared more about their political ambitions than about their responsibility to lead the people to God. Though religious leaders, they had become evil. . . . Instead of honestly evaluating Jesus' claims based on their knowledge of Scripture, these religious leaders sought to further their own selfish ambitions and were even willing to kill God's Son, if that's what it took, to do it.

—LIFE APPLICATION BIBLE COMMENTARY—JOHN

HOUSE OF ANNAS, NOW CHURCH OF THE
HOLY ARCHANGEL, JERUSALEM, ISRAEL *(left)*
INTERIOR, CHURCH OF THE
HOLY ARCHANGEL, HOUSE OF ANNAS *(inset)*
Here Jesus was brought before Annas.

THEN ANNAS *sent* HIM,

STILL BOUND,

TO CAIAPHAS THE

high PRIEST.

(JOHN 18:24)

STEPS TO CAIAPHAS'S HOUSE, KIDRON VALLEY,
JERUSALEM, ISRAEL

These ancient steps date from before the time of Jesus, and he would have walked on them. This path is most likely the way Jesus was brought to Caiaphas's house.

This was not a trial but a farce. There was no intention of giving Jesus the opportunity to declare His innocence of their trumped-up notions. Motivated by envy, they had already decided that Jesus must die. . . .

But what of the attitude and actions of Christ? What a lesson in integrity! He had spoken openly during his three years of ministry in Palestine, he told them, and by checking they could verify his claims. Jesus also gave us an object lesson in meekness. We witness here the drama of his absolute power under absolute control. This was not simply quietness or human niceness, a gentle personality, if you like. It was certainly not a lack of conviction. It was this Jesus who had forcefully cleared the temple of the moneychangers. Here we see the dignity and majesty of Jesus as he was confronted by despicable individuals seeking to make a mark on history by leaving a mark on Christ.

. . . As we read the Gospels, it is clear that Jesus died not as the helpless victim of evil forces, nor as a result of some inflexible decree, but because he freely submitted to the Father's plan. He had come to do the will of the Father.

—ALISTAIR BEGG

VIA DOLOROSA, JERUSALEM

The Via Dolorosa, "Way of Sorrow" or "Way of the Cross," is Christendom's most sacred route.
It follows the path Jesus took from Pilate's judgment to his place of crucifixion.

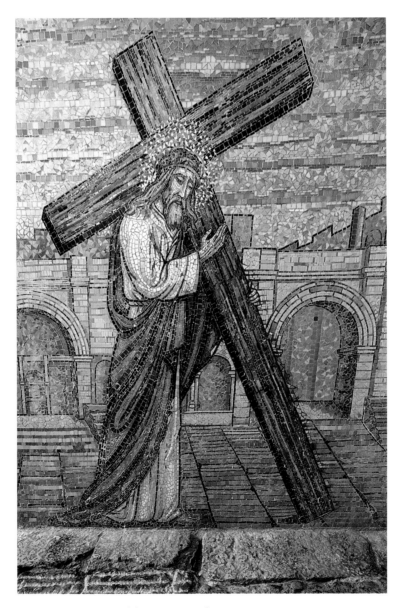

MOSAIC OF JESUS CARRYING HIS CROSS,
LITHOSTROTOS, JERUSALEM, ISRAEL

Steps to the Cross

Jesus' final steps were as purposeful as they were painful. He dragged his cross and the weight of human sin up the hill called "The Skull." Scripture and tradition mention several stops along the way, but the crucial fact is that Jesus never really stopped. He walked all the way to the place of crucifixion and allowed people like us to nail him to the timbers and raise him high. He deliberately stayed on the cross. The nails certainly didn't hold him in place; his love did. His experience gives the original meaning to the word *excruciating.* But Jesus faced it for a reason: "Let us fix our eyes on Jesus, the author and perfecter of our faith, *who for the joy set before him endured the cross, scorning its shame, and sat down at the right hand of the throne of God*" (Hebrews 12:2, emphasis added). Jesus faced the cross with joy on his mind.

Betrayal, abandonment, injustice, abuse, and faint echoes of love filled Jesus' last hours. He walked his final steps so that we would never have to run the same gauntlet. He took our place. The identification with us as humans that began in Mary's womb reached its deepest significance when he identified with us as sinners on the cross. Once that purpose had been accomplished, his work was completed. No wonder he cried from the cross, "It is finished!"

THE PRISON OF CHRIST, GREEK ORTHODOX CHURCH, JERUSALEM

This Greek Orthodox Church is thought to have been the prison where Jesus was held before his trial.

AS SOON AS THE CHIEF *priests* AND THEIR OFFICIALS SAW HIM,

THEY SHOUTED, "CRUCIFY! CRUCIFY!" . . .

FINALLY PILATE HANDED *him* OVER

TO THEM TO BE CRUCIFIED.

(JOHN 19:6, 16)

Finally, Pilate handed him over to be crucified. In many ways Pilate is a most pitiable character, for he lived in fear on every side. He feared Caesar, if perchance he conveyed that he did not deal with someone who was a threat to Rome. He feared the implications of what he was doing, because his wife had warned him that she had had a dream about Jesus and that he should not have a share in punishing that innocent man. He feared Jesus himself, not quite sure who he was dealing with.

Pilate may well be the quintessential example of what politics has come to mean. He knew what was right but succumbed to the seduction of his position. In life's most severe tests of motives, there is a politician in each and every one of us. While Pilate was ignorant of the role he was playing, the priests justified their heinous deed, quoting Scripture in support of their cause. Divine purpose, political maneuvering, and religious fervor met in the plan of redemption.

—RAVI ZACHARIAS

ECCE HOMO ARCH, JERUSALEM

According to tradition, this is the spot where Pilate presented Jesus to the Jews and proclaimed, "Ecce homo"—"Behold the man."

THEY *spit* ON HIM,
AND TOOK THE *staff*
AND STRUCK HIM
ON THE *head* AGAIN
AND AGAIN.
AFTER THEY HAD
mocked HIM, THEY
TOOK OFF THE ROBE
AND PUT *his* OWN
CLOTHES ON HIM.
THEN THEY
LED HIM AWAY
TO *crucify* HIM.

(MATTHEW 27:30–31)

JESUS TAKES UP HIS CROSS,
THE LITHOSTROTOS, JERUSALEM

This paving is in the courtyard of the Antonia Fortress.
On this pavement Jesus took up his cross and began his
grueling trek to his crucifixion.

The most notorious road in the world is the Via Dolorosa, "the Way of Sorrows." According to tradition, it is the route Jesus took from Pilate's hall to Calvary. . . . There are fourteen stations in all, each one a reminder of the events of Christ's final journey.

Is the route accurate? Probably not. When Jerusalem was destroyed in A.D. 70 and again in A.D. 135, the streets of the city were destroyed. As a result, no one knows the exact route Christ followed that Friday.

But we do know where the path actually began.

The path began, not in the court of Pilate, but in the halls of heaven. The Father began his journey when he left his home in search of us. Armed with nothing more than a passion to win your heart, he came looking. His desire was singular—to bring his children home. The Bible has a word for this quest: *reconciliation*. . . .

Reconciliation touches the shoulder of the wayward and woos him homeward.

The path to the cross tells us exactly how far God will go to call us back.

—MAX LUCADO

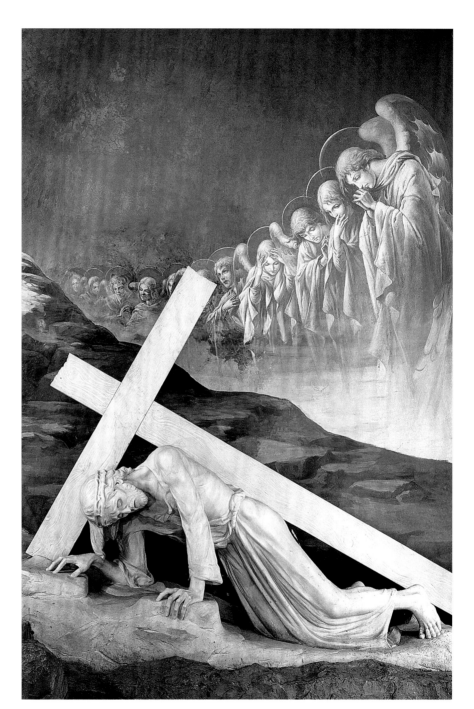

JESUS FALLS FOR THE FIRST TIME, VIA DOLOROSA, JERUSALEM

MARY MEETS JESUS, VIA DOLOROSA, JERUSALEM

A CERTAIN MAN FROM CYRENE, SIMON,

THE *father* OF ALEXANDER AND RUFUS,

WAS PASSING BY ON HIS WAY IN FROM THE COUNTRY,

AND THEY *forced* HIM TO CARRY THE CROSS.

(MARK 15:21)

For Simon it was just a hunk of wood. He was strong and the Romans had swords. He would carry it.

For us, it's a cross, a symbol rich in meaning, and the man Simon helped was the world's Savior. Who wouldn't do as much? If we were there, we would gladly have come forward to help Jesus.

We bear the cross, not because we love pain, but because Jesus loves us. It's the Christians' way of saying to everyone: I have died with Christ, this Savior has first place in my heart, and I will serve him as Lord.

Today the cross comes in different shapes. Christians must shoulder it when they suffer loss for Christ's sake—enduring a dread disease, losing a friend or a job, remaining chaste while unmarried, and a thousand more. Let us carry the cross courageously.

—LIFE APPLICATION
　　BIBLE COMMENTARY—MARK

SIMON OF CYRENE HELPS CARRY THE CROSS OF JESUS,
VIA DOLOROSA, JERUSALEM

JESUS CONSOLES THE WOMEN OF JERUSALEM, VIA DOLOROSA, JERUSALEM

This marks the traditional location where Jesus consoled the women of Jerusalem.

JESUS TURNED AND *said* TO THEM,

"DAUGHTERS OF JERUSALEM, DO NOT WEEP FOR ME;

WEEP FOR YOURSELVES AND FOR YOUR *children*."

(LUKE 23:28)

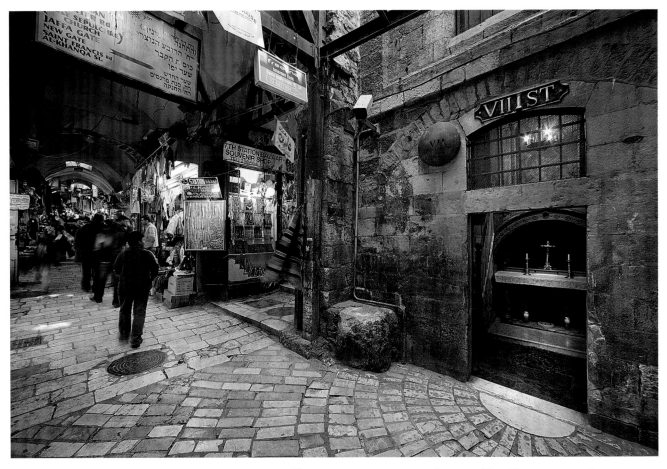

THE SECOND FALL OF JESUS, VIA DOLOROSA, JERUSALEM

I started with Matthew, which is one of the Gospels about Jesus. And I read through Matthew and Mark, then Luke and John. I read those books in a week or so, and Jesus was very confusing, and I didn't know if I liked him very much, and I was certainly tired of him by the second day. By the time I got to the end of Luke, to the part where they were going to kill him again, where they were going to stretch him out on a cross, something shifted within me. . . . I felt a love for him rush through me, through my back and into my chest. I started crying, too. . . .

Sometimes when I go forward at church to take Communion, to take the bread and dip it in the wine, the thought of Jesus comes to me, the red of his blood or the smell of his humanity, and I eat the bread and I wonder at the mystery of what I am doing, that somehow I am one with Christ, that I get my very life from him, my spiritual life comes from his working inside me, being inside me.

—DONALD MILLER

Where Jesus Walked

WHEN THE SOLDIERS *crucified* JESUS,

THEY TOOK HIS CLOTHES, *dividing* THEM INTO FOUR SHARES,

one FOR EACH OF THEM, WITH THE UNDERGARMENT REMAINING.

(J O H N 1 9 : 2 3)

Though we find it hard and even repulsive to imagine, Jesus was only one of many people tortured to death by crucifixion. He had two companions at the brow of Calvary. But his experience on the cross included several added sobering features. A unique death for a unique man:

First, it was shameful. He was stripped of his clothing and pinned naked between heaven and earth. There's no mention of the soldiers casting lots for the clothing of the other victims. He was ridiculed by the crowds and taunted by one of the criminals. Jesus suffered the humiliation of the sign posted over his head that attempted to mock his claim to be king.

Second, he was absolutely innocent—and he could prove it! He was there by choice. The nails didn't keep him on the cross. His decision to remain there was stronger than his desire to avoid the pain. Think for a moment how tempting it must have been to have a self-pity party.

Third, he bore the sins of the world—including yours and mine—on the cross.

Fourth, he sensed the forsaking action of God as his Father turned away from him, covered as he was in our sins.

—NEIL WILSON

THE PLACE OF THE SKULL, A POSSIBLE LOCATION
FOR GOLGOTHA, JERUSALEM *(left)*

*Here is one area that many believe to be the location for "Golgotha," the place of Jesus'
crucifixion. This location fits descriptions of Golgotha because it is outside the city
gate but still close to the city. In addition, the cliff or knoll close
to the Garden Tomb has a shape that resembles a skull.*

VIA DOLOROSA, JERUSALEM *(inset)*

*According to tradition, Jesus collapsed not far from where he would be crucified. The Roman
column on the left hand side of the gate indicates the location of this fall.*

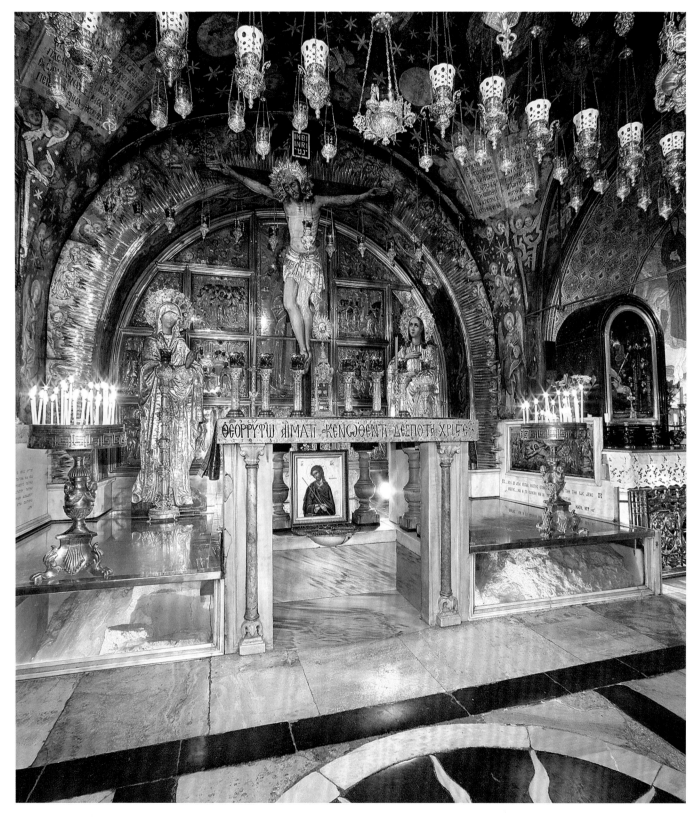

Where Jesus Walked

AT THE SIXTH HOUR *darkness* CAME OVER THE WHOLE *land* UNTIL THE NINTH HOUR.

(MARK 15:33)

Jesus did not come merely to disclose God's character. He came to make it possible to be remade in the likeness of that character. He came to redeem us from what we are and to remake us in the likeness of what he is. He is not merely a teacher, a doer—he is a redeemer.

He came not merely to give his word, his example. He came to give himself. He became like us that we might become like him. . . . He became sin for us at the cross. He died between two malefactors like one of them and cried the cry of dereliction that you and I cry when we sin: "My God, my God, why hast thou forsaken me?" (Matthew 27:46, KJV). If "life is sensitivity," then here was infinite life, for here was infinite sensitivity—every man's hunger his hunger; every man's bondage his bondage; and every man's sin his sin. "He himself bore our sins in his body on the tree" (1 Peter 2:24). Don't ask me to explain it. I can't explain it; I bow in humility and repentance at the cross, at the wonder of it, that God should give himself for me. I bow and am redeemed!

—E. STANLEY JONES

JESUS DIES ON THE CROSS, THE CHURCH OF THE HOLY SEPULCHRE, JERUSALEM

The Church of the Holy Sepulchre has been built on what some believe to be Golgotha or Calvary. This photograph shows the altar built on the very place where Jesus was supposedly crucified. On either side of the altar are impressions from the crosses of the thieves that were crucified with Jesus. The bedrock below this altar is believed to be the original rock of Golgotha. The large crack in this rock, according to tradition, was caused by the miraculous weather accompanying Jesus' death.

JESUS CALLED OUT WITH A *loud* VOICE,

"FATHER, INTO YOUR HANDS I COMMIT MY SPIRIT."

WHEN HE HAD SAID THIS, HE *breathed* HIS LAST.

(LUKE 23:46)

The interior journey of the soul from the wilds of sin into the enjoyed Presence of God is beautifully illustrated in the Old Testament tabernacle. The returning sinner first entered the outer court where he offered a blood sacrifice on the brazen altar and washed himself in the laver that stood near it. Then through a veil he passed into the holy place where no natural light could come, but the golden candlestick which spoke of Jesus the Light of the World threw its soft glow over all. There also was the shewbread to tell of Jesus, the Bread of Life, and the altar of incense, a figure of unceasing prayer. . . . Another veil separated from the Holy of Holies where above the mercy seat dwelt the very God Himself in awful and glorious manifestation. While the tabernacle stood, only the high priest could enter there, and that but once a year, with blood which he offered for his sins and the sins of the people. It was this last veil which was rent when our Lord gave up the ghost on Calvary and . . . This rending of the veil opened the way for every worshiper in the world to come by the new and living way straight into the divine Presence.

—A. W. TOZER

Where Jesus Walked

AS EVENING APPROACHED, THERE CAME A *rich* MAN

FROM ARIMATHEA, NAMED JOSEPH, WHO HAD HIMSELF BECOME

A *disciple* OF JESUS. GOING TO PILATE, HE ASKED FOR JESUS' BODY,

AND PILATE ORDERED THAT IT BE GIVEN TO HIM.

JOSEPH *took* THE BODY, WRAPPED IT IN A CLEAN LINEN CLOTH.

(MATTHEW 27:57–59)

They took the body down from the cross and one of the few rich men among the first Christians obtained permission to bury it in a rock tomb in his garden; the Romans setting a military guard lest there should be some riot and attempt to recover the body. There was once more a natural symbolism in these natural proceedings; it was well that the tomb should be sealed with all the secrecy of ancient eastern sepulture and guarded by the authority of the Caesars. For in that second cavern the whole of that great and glorious humanity which we call antiquity was gathered up and covered over; and in that place it was buried. It was the end of a very great thing called human history; the history that was merely human. . . .

On the third day the friends of Christ coming at daybreak to the place found the grave empty and the stone rolled away. In varying ways they realized the new wonder; but even they hardly realized that the world had died in the night. What they were looking at was the first day of a new creation, with a new heaven and a new earth.

—G. K. CHESTERTON

JESUS TAKEN OFF THE CROSS, CHURCH OF THE HOLY SEPULCHRE, JERUSALEM

After Jesus was taken down from the cross, he was laid on the stone of anointing. That stone is still there and is in the foreground of this photograph.

TAKING JESUS' BODY, THE TWO OF THEM *wrapped* IT,

WITH THE SPICES, IN STRIPS OF LINEN. . . .

AT THE PLACE WHERE JESUS WAS *crucified,*

THERE WAS A GARDEN, AND IN THE GARDEN A NEW TOMB,

IN WHICH NO ONE HAD *ever* BEEN LAID.

(JOHN 19:40–41)

THE GARDEN TOMB, JERUSALEM, ISRAEL

This garden area and tomb gives the impression and feeling of what Jesus' burial place would have originally looked like.

Nicodemus and Joseph brought a sack of myrrh and aloes and, along with spices and strips of cloth, they wrapped Jesus' body in keeping with Jewish custom. But his enemies were nervous. They went to Pilate and asked to have a guard placed around the tomb because they feared the body would be stolen by his disciples who would then claim that he had risen from the dead, just as he had declared he would.

This I find startling. Utterly startling! Jesus' enemies evidently knew what Jesus meant better than his own followers did. The disciples were hiding in fear of being arrested and sharing in Jesus' fate. But his enemies evidently understood that Jesus had said that he would rise again from the dead after three days. Often, those who reject the message have greater fears that there might be a haunting truth to it than those who claim to believe it. They took extra precautions to guard against it. However, they could not permanently fight off God.

—RAVI ZACHARIAS

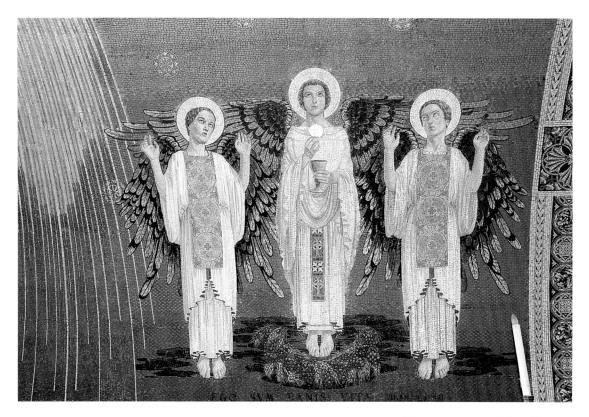

MOSAIC FROM MT. TABOR

Unending Journey

One Sunday morning, centuries ago, a vacancy sign went up outside a tomb in Jerusalem. That never happens—in Jerusalem or anywhere. Tombs are empty or full—never vacant. That would mean that someone had occupied the space and then had vacated it. Dead people don't vacate.

Jesus did.

But not because he was dead. First, he left death and then the grave behind. He arose! He was seen walking, talking, and eating. Those who had seen his hands and feet nailed to the Cross thought it was over, that Jesus would never walk again. His death confirmed their fears. But they had forgotten he had foreseen their confusion and had encouraged them to be patient. They only had to wait three days.

These early followers were too afraid to wait—too ashamed to wait—too devastated to wait. So they were surprised! And they went from being stunned by his death to being overwhelmed by his resurrection. They were changed.

Jesus rose bodily. That means, among other things, that he had more walking to do, more steps to take. The promise of the resurrection includes this amazing thought: we will spend eternity walking where Jesus walked. And he will walk with us.

ON THE *first* DAY OF THE WEEK, VERY EARLY IN THE MORNING,

THE WOMEN TOOK THE SPICES THEY HAD *prepared*

AND *went* TO THE TOMB. THEY FOUND THE STONE

ROLLED AWAY FROM THE TOMB, BUT *when* THEY ENTERED,

THEY DID NOT *find* THE BODY OF THE LORD JESUS.

(LUKE 24:1–3)

On the third day after his death the Bible says, "And behold, there was a great earthquake: for the angel of the Lord descended from heaven, and came and rolled back the stone from the door, and sat upon it. His countenance was like lightning, and his raiment white as snow: And for fear of him the keepers did shake, and became as dead men" (Matthew 28:2–4, KJV).

Though some Bible students have tried to estimate how much this stone weighed, we need not speculate because Jesus could have come out of that tomb whether the stone was there or not. The Bible mentions it so that generations to come can know something of the tremendous miracle of resurrection that took place.

As Mary looked into the tomb she saw "two angels in white sitting, the one at the head, and the other at the feet, where the body of Jesus had lain" (John 20:12, KJV). Then one of the angels who was sitting outside the tomb proclaimed the greatest message the world has ever heard: "He is not here: for he is risen" (Matthew 28:6, KJV). Those few words changed the history of the universe. Darkness and despair died; hope and anticipation were born in the hearts of men.

—BILLY GRAHAM

TOMB DOOR, THE GARDEN TOMB

NOW THAT SAME DAY *two* OF THEM

WERE GOING TO A VILLAGE CALLED EMMAUS,

ABOUT SEVEN MILES FROM *Jerusalem.*

(LUKE 24:13)

Where Jesus Walked

TEMPLE AT EMMAUS, AYALON VALLEY

Were the scene not so common it would be comical. Two heavy-hearted disciples slouching their way home to Emmaus. By the slump in their shoulders, you'd never know today was Resurrection Sunday. By the looks on their faces, you'd think Jesus was still in the tomb. . . .

The first mistake of the duo was to disregard the words of their fellow disciples. God reveals his will through a community of believers. On the first Easter, he spoke through women who spoke to the others. . . .

His plan hasn't changed. Jesus still speaks to believers through believers. . . .

That, by the way, is why Satan doesn't want you in church. You've noticed, haven't you, that when you're in a spiritual slump, you head out to Emmaus, too. . . .

Mark it down: Jesus comes to set you on fire! He walks as a torch from heart to heart, warming the cold and thawing the chilled and stirring the ashes. . . .

The fire of your heart is the light of your path. Disregard it at your own expense. Fan it at your own delight. Blow it. Stir it. Nourish it. Cynics will doubt it. Those without it will mock it. But those who know it—those who know *him*—will understand it.

—MAX LUCADO

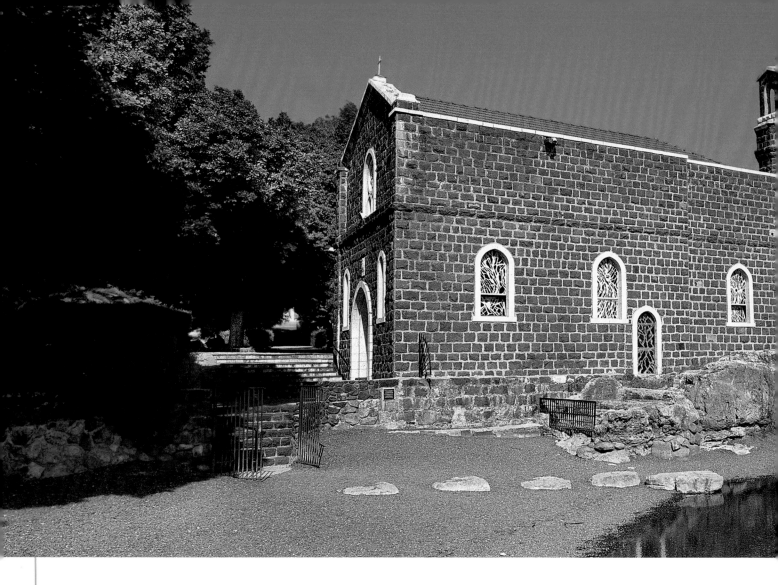

EARLY IN THE MORNING,
JESUS STOOD ON THE SHORE, BUT THE *disciples* DID NOT
REALIZE THAT IT WAS JESUS.

(JOHN 21:4)

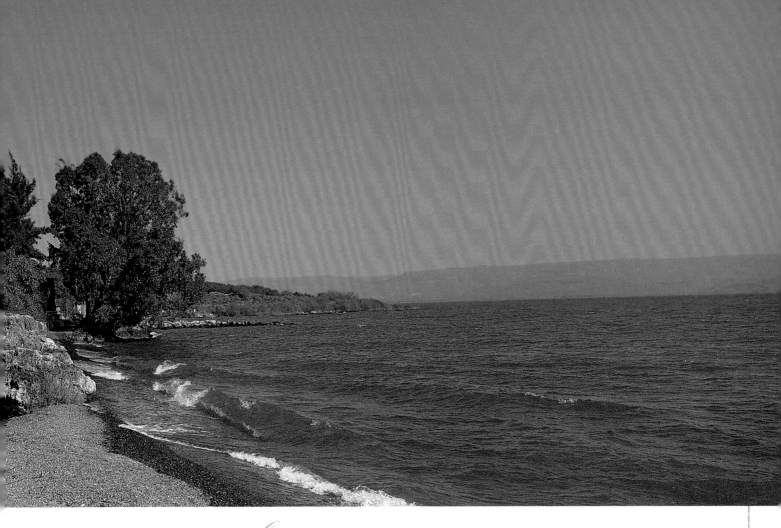

Thought to be where Jesus appreared to his disciples.

Some interpreters find it difficult to imagine that the disciples, after two memorable encounters with Jesus in Judea and having heard his command to go into the world, would then waste time fishing in Galilee. I am not so sure! It takes time for the pieces to fit together in a person's life, especially if the way of discipleship has freedom in it. Peter has experienced the victory of Christ and he is glad of that true event. But he had fallen hard in his denial of Jesus. It takes time for a person to resolve the feelings of depression that result from a moral defeat like denial. What can Peter do? In his own eyes, before himself, he is discredited. . . .

It makes sense to me that Peter is doing what you and I would tend to do with feelings of loose ends. He returns to what he knows best and feels good about. He may not be a great man of faith, but a fisherman he is. It is my view that a depressed Peter decides to go fishing, and just as the disciples had stayed with Thomas through his battle for faith, so now they stay with a struggling Peter through his lonely battle.

—EARL F. PALMER

WHEN HE HAD LED THEM OUT TO THE VICINITY OF BETHANY,

HE LIFTED UP HIS HANDS AND *blessed* THEM.

WHILE HE WAS BLESSING THEM,

HE LEFT THEM AND WAS TAKEN UP INTO *heaven*.

(LUKE 24:50–51)

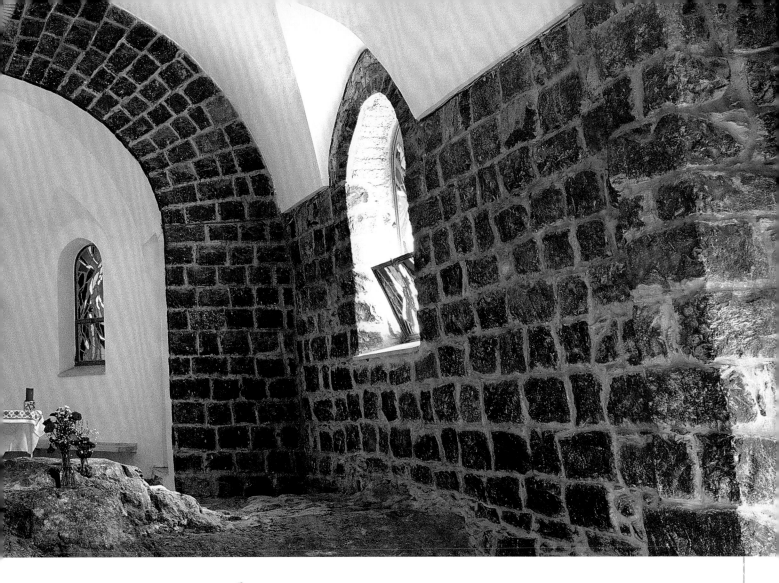

INTERIOR OF THE CHURCH OF THE
PRIMACY OF ST. PETER,
SEA OF GALILEE, ISRAEL

*The rock shelf in the foreground is
called the Mensa Christi ("Christ's Table")
and is believed to be the rock shelf on which
Jesus had breakfast with his disciples.*

Why did the disciples stand and look intently into the sky? Maybe they were stunned and amazed at seeing Jesus ascend into the air through the clouds. They may have been saddened by his sudden disappearance and were looking anxiously for him to descend. Or perhaps they were confused and didn't know what else to do.

Whatever their thoughts or motives, however, two angels ("white-robed men," NLT) gave them the word. They could stop looking up and start looking around at the world and its needy people (John 4:35). They could stop waiting and start working to fulfill Christ's commission (Matthew 28:18–20). They could stop wondering and start living with the assurance that Jesus would come again, just as he had promised (John 14:3).

Although nearly two thousand years have passed since this dramatic event, the angels' message still stands—Jesus will surely return. That truth should continue to motivate believers. In fact, each day that passes provides another day to work for Christ and his kingdom.

Keep hoping, working, loving, sharing the Good News, and living for the Savior. He will come back.

—DAVE VEERMAN

HE *who* TESTIFIES
TO THESE
THINGS SAYS,
"YES, I AM
coming SOON."
AMEN. COME,
LORD JESUS.

(REVELATION 22:20)

THE EASTERN GATES,
JERUSALEM, ISRAEL

The Bible says that Christ will return at this location.
These Eastern Gates to Jerusalem will open when
the time is right to receive the King of kings,
Jesus Christ, the Son of God.

[ENDNOTES]

page 3: C. H. Spurgeon, *Morning and Evening: Daily Readings* (Grand Rapids, MI: Christian Classics Ethereal Library, 2001), Morning, December 25, http://www.ccel.org/ccel/spurgeon/morneve.htm.

page 5: Neil Wilson, *365 Life Lessons from Bible People* (Wheaton, IL: Tyndale House, 1996), p. 269.

page 7: Bruce B. Barton, Dave Veerman, and Linda K. Taylor, *Luke*, Life Application Bible Commentary, ed. Grant Osborne and Philip Comfort (Wheaton, IL: Tyndale House, 1997), pp. 39–40.

page 9: Bill Bright, *Discover the Real Jesus* (Wheaton, IL: Tyndale House, 2004), pp. 31–32.

page 11: Billy Graham, *Unto the Hills* (Dallas, TX: Word, 1996), pp. 446–447.

page 13: David E. Rosage, *Listen to Him: A Daily Guide to Scriptural Prayer* (Ann Arbor, MI: Servant, 1981), p. 4.

page 15: Martin Luther, *By Faith Alone* (Cedar Rapids, IA: World, 1998), December 28.

page 19: Richard B. Gardner, Matthew, *Believers Church Bible Commentary* (Scottdale, PA: Herald, 1991), pp. 54, 55, 57.

page 21: Henry Gariepy, *100 Portraits of Christ* (Wheaton, IL: Victor, 1987, 1993), pp. 75–76.

page 23: David L. McKenna, *The Jesus Model* (Waco, TX: Word, 1977), pp. 40–41.

page 25: Beth Moore, *Jesus, the One and Only* (Nashville, TN: Broadman & Holman, 2002), pp. 44–46.

page 29: David E. Garland, *Mark*, The NIV Application Commentary (Grand Rapids, MI: Zondervan, 1996), pp. 53–54.

page 31: Beth Moore, *Praying God's Word* (Nashville, TN: Broadman & Holman, 2000), pp. 188–90.

page 33: Joseph M. Stowell, *Simply Jesus* (Sisters, OR: Multnomah, 2002), p. 62.

page 35: Michael Green, *The Message of Matthew: The Kingdom of Heaven, The Bible Speaks Today*, ed. John Stott (Downers Grove, IL: InterVarsity, 1988, 2000), p. 83.

page 37: Earl F. Palmer, *The Intimate Gospel* (Waco, TX: Word, 1978), p. 36.

page 39: Max Lucado, *A Gentle Thunder* (Nashville, TN: W Publishing, 1995), pp. 21, 23.

page 41: Tom Wright, *Matthew for Everyone, Part 1* (London: SPCK, 2002), pp. 31–32.

page 43: Liz Curtis Higgs, *Bad Girls of the Bible* (Colorado Springs, CO: WaterBrook, 1999), pp. 91–92.

page 45: John R. W. Stott, *Christ the Controversialist* (Downers Grove, IL: InterVarsity, 1972), pp. 165–66.

page 47: Howard A. Snyder, *The Problem of Wine Skins: Church Structure in a Technological Age* (Downers Grove, IL: Inter-Varsity, 1975), pp. 15–16.

page 49: Dietrich Bonhoeffer, *The Cost of Discipleship* (New York: Macmillan, 1959; New York: Touchstone, 1995), pp. 202–203.

page 53: John MacArthur, *Hard to Believe* (Nashville, TN: Thomas Nelson, 2003), pp. 60–61, 63, 69.

page 55: John R. W. Stott, *Christ the Controversialist* (Downers Grove, IL: InterVarsity, 1972), p. 210.

page 57: John Calvin, *Commentary on John*, transl. William Pringle (1847; Grand Rapids, MI: Christian Classics Ethereal Library), vol. 1, chap. 5, http://www.ccel.org/ccel/calvin/calcom34.html.

page 59: William Barclay, *The Gospel of John*, rev. ed., The Daily Study Bible Series, rev. ed. (Philadelphia: Westminster, 1975), pp. 174–175.

page 61: Kay Arthur, *Lord, Only You Can Change Me: A Devotional Study on Growing in Character from the Beatitudes* (Sisters, OR: Multnomah, 1995; Colorado Springs, CO: WaterBrook, 2000), pp. 23–24.

page 63: Rick Ezell, *Sightings of the Savior* (Downers Grove, IL: InterVarsity Press, 2003), pp. 109, 111.

page 65: C. H. Spurgeon, *Morning and Evening: Daily Readings* (Grand Rapids, MI: Christian Classics Ethereal Library, 2001), Evening, August 9, http://www.ccel.org/ccel/spurgeon/morneve.htm.

page 67: Max Lucado, *When Christ Comes* (Nashville, TN: W Publishing, 1999), pp. 102–103.

page 69: W. Phillip Keller, *Rabboni* (Old Tappan, NJ: Fleming H. Revell, 1977), pp. 148–149.

page 71: Rick Ezell, *Sightings of the Savior.* (Downers Grove, IL: InterVarsity, 2003), p. 70.

page 75: John Ortberg, *If You Want to Walk on Water, You've Got to Get Out of the Boat* (Grand Rapids, MI: Zondervan, 2001), p. 15.

page 77: Robert E. Webber, *Journey to Jesus* (Nashville, TN: Abingdon, 2001), p. 186.

page 79: E. M. Bounds, *The Necessity of Prayer* (Grand Rapids, MI: Christian Classics Ethereal Library, 2000), chap. 6, http://www.ccel.org/ccel/bounds/necessity.htm.

page 81: John Piper, *The Passion of Jesus Christ* (Wheaton, IL: Crossway, 2004), p. 55.

page 83: William Barclay, *The Gospel of Matthew*, rev. ed., The Daily Study Bible Series, rev. ed. (Philadelphia: Westminster, 1975), p. 138.

page 85: David Jeremiah, *Life Wide Open* (Nashville, TN: Integrity, 2003), pp. 130–31.

page 87: J. C. Ryle, Matthew, *The Crossway Classic Commentaries*, ed. Alister McGrath and J. I. Packer (Wheaton, IL: Crossway, 1993), pp. 148–149.

page 89: Oswald Chambers, *My Utmost for His Highest: an Updated Edition in Today's Language* (Grand Rapids: Discovery House, 1992), October 1.

page 91: Joni Eareckson Tada, *More Precious Than Silver*, (Grand Rapids, MI: Zondervan, 1998), April 14.

page 93: Claire Cloninger, *101 Most Powerful Prayers in the Bible* (New York: Warner, 2003), p. 196.

page 95: Joseph Stowell, *Following Christ*. (Grand Rapids, MI: Zondervan, 1996), p. 123.

page 99: Frederick Buechner, *Telling the Truth* (San Francisco: Harper and Row, 1977), pp. 66, 68.

page 101: Bruce B. Barton, David Veerman, and Linda K. Taylor, *Luke*, Life Application Bible Commentary, ed. Grant Osborne and Philip Comfort (Wheaton, IL: Tyndale House, 1997), p. 396.

page 103: Max Lucado, *In the Grip of Grace* (Dallas: Word, 1996), pp. 64–65.

page 105: Bruce B. Barton, Mark Fackler, et al, *Matthew*, Life Application Bible Commentary, ed. Grant Osborne and Philip Comfort (Wheaton, IL: Tyndale House, 1996), p. 417.

page 107: Greg Laurie, *Breakfast with Jesus* (Wheaton, IL: Tyndale House, 2003), pp. 63–64.

page 109: Neil Wilson, *365 Life Lessons from Bible People* (Wheaton, IL: Tyndale House, 1996) p. 284.

page 113: Michael Card, *The Name of the Promise Is Jesus* (Nashville, TN: Thomas Nelson, 1993), pp. 142–144.

page 115: David Jeremiah, *God in You*, (Sisters, OR: Multnomah, 1998), pp. 136–137.

page 117: Augustine, *Expositions of the Psalms: 121-150*, transl. Maria Boulding, The Works of Saint Augustine: A Translation for the 21st Century, ed. Boniface Ramsey (Hyde Park, NY: New City, 2004), pp. 452–453.

page 119: Anthony Campolo, *The Power Delusion* (Wheaton, IL: Victor, 1984), p. 89.

page 121: Max Lucado, *The Applause of Heaven* (Dallas, TX: Word, 1990), pp. 93–94.

page 123: Len Woods, *Praying God's Promises in Tough Times* (Wheaton, IL: Tyndale House, 2002), p. 146.

page 125: Ravi Zacharias, *Recapture the Wonder* (Nashville, TN: Integrity Publishers, 2003), p. 157.

page 127: Neil Wilson, *His Passion: Christ's Journey to the Resurrection* (Brentwood, TN: Integrity, 2004), p. 169.

page 129: Bruce B. Barton, Philip W. Comfort, et al, *John*, Life Application Bible Commentary (Wheaton, IL: Tyndale House, 1993), pp. 355–356.

page 131: Alistair Begg, *What the Angels Wish They Knew* (Chicago: Moody, 1998), pp. 113–114.

page 135: Ravi Zacharias, *Jesus Among Other Gods* (Nashville, TN: W Publishing, 2000), p. 152.

page 137: Max Lucado, *He Chose the Nails* (Nashville, TN: W Publishing, 2000), pp. 63–64.

page 139: Bruce B. Barton, Mark Fackler, et al, *Mark*, The Life Application Bible Commentary, ed. Grant Osborne and Philip Comfort (Wheaton, IL: Tyndale House, 1994), p. 460.

page 141: Donald Miller, *Blue Like Jazz* (Nashville, TN: Thomas Nelson, 2003), pp. 236–237.

page 143: Neil Wilson, *His Passion: Christ's Journey to the Resurrection* (Brentwood, TN: Integrity, 2004), p. 238.

page 145: E. Stanley Jones, *A Song of Ascents* (Nashville, TN: Abingdon, 1968), p. 377.

page 147: A. W. Tozer, *The Pursuit of God* (Harrisburg, PA: Christian Publications, 1948), pp. 35–36.

page 149: G. K. Chesterton, *The Everlasting Man* (New York: Image, 1955), pp. 216–17.

page 151: Ravi Zacharias, *Jesus Among Other Gods* (Nashville, TN: W Publishing), p. 143.

page 155: Billy Graham, *Unto the Hills* (Dallas, TX: Word Publishing, 1996), p. 135.

page 157: Max Lucado, *The Great House of God* (Dallas, TX: Word, 1997), pp. 69, 73–74, 78–79.

page 159: Earl F. Palmer, *The Intimate Gospel* (Waco, TX: Word, 1978), p. 175.

page 161: David R. Veerman, *Beside Still Waters* (Wheaton, IL: Tyndale House, 1996), Day 69.